LOST
METAIRIE

LOST
METAIRIE

CATHERINE CAMPANELLA

THE
History
PRESS

Published by The History Press
Charleston, SC
www.historypress.net

Front cover: Louisiana Digital Library, Charles L. Franck/Franck-Bertacci Photographers
Collection, the Historic New Orleans Collection.
Back cover, top: *Times-Picayune*, *Weekly Business Bulletin*, December 10, 1942, care of Maunsel
White. *Bottom*: Louisiana Digital Library, Charles L. Franck/Franck-Bertacci Photographers
Collection, the Historic New Orleans Collection.

First published 2017

Manufactured in the United States

ISBN 9781625858733

Library of Congress Control Number: 2017938337

This book is dedicated to my beloved grandchildren, Lily and Jack.

CONTENTS

ACKNOWLEDGEMENTS

Special thanks to Lynn Markey Accardo, Laverne Forson Patrick Amore, Noel Singer Belew, Laverne Patrick Cannard, Tabitha Diecedue, Steve Duplantis, Susan Weaver Eble, Margie Vicknair-Pray, Donna Schlaudecker and Roy Schlaudecker for personally sharing their memories and photos of Bucktown, and to Maunsel White for his enthusiastic interest and sharing of all things pertaining to Old Metairie. I would like to acknowledge the late Bruce Boudreaux, who was also a great lover of Metairie history and writer of the *Times-Picayune* Old Metairie/Jefferson column.

Thanks to Cherie Chatelain Creasy for her help while researching the Native American mounds and middens, and to Bob Walker and Jay Delerno for information about Delerno's restaurant. Other contributors include Mike Azzarello, Henry Bauer, Christle Bertoniere, Dolly Breaux, Cindy Patrick Burnette, Reid Butler III, Meredith and Vincent Campanella, Rosanna Ovella Chauvin, Tammy Diecidue, Earl Hampton, Liddy Hanemann, Nancy Root Howard, Darren Jones, John J. Morella, Pam Patrick, Sebastian Junior Scontrino, Janet Patton Swann, Sid Vicknair and Cj Ybos.

INTRODUCTION

Jefferson Parish, incorporated in 1825 (a mere eighteen years after New Orleans was established), was named to honor the living former president Thomas Jefferson for his work in negotiating the Louisiana Purchase. However, the parish's founders had originally proposed to name it Tchoupitoulas Parish.

The first record of the land that would become Metairie is the Concession of 1720, also called the Chapitoulas Concession, named for the "river people" who lived along a bayou on a high natural ridge that cut through cypress swamps from Kenner to Bayou St. John. Through the years, the name "Chapitoulas" evolved into "Tchoupitolas." The bayou (originally named Tchoupitoulas, then Bayou Metairie) would slowly disappear—European settlers dammed it at the river in order to drain land for farming. The ridge would become the bed of Metairie Road.

The oldest entities lost from Metairie's history are the former habitations of Native Americans along the ridge and near Lake Pontchartrain. A series of bayous once flowed from the lake: Indian Bayou, Bayou Labarre, Bayou Laurier/Loria/Loriet, Double Bayou and another named Bayou Tchoupitoulas (possibly the remains of the original). The native people used these waterways and settled near them, constructing mounds and middens (locals called these the "Indian Mounds") with clams from the lake.

Early European property holdings ran from the lake to the river, and what could be seen from the few roads was a minuscule portion of the land possessed. Free persons of color owned large tracts at the outset of Metairie's

development. These people included the following: Angélique Aury, who obtained property from Pierre Langliche (also a free person of color), who had acquired it on October 1, 1787, from Spanish colonial notary and real estate developer Andres Almonester y Roxas; Marie Joseph and Jean Louis Beaulieu, who acquired adjacent land from Langliche on March 14, 1794; and George and Jean L'Esprit, who had property holdings before 1832; the three Hazeur brothers, who established a plantation on both sides of the Seventeenth Street Canal. (Sylvain and Jean Baptiste Hazeur sold their property on January 15, 1870; their brother T.H. sold his adjoining land on April 13, 1878.)

In the 1850s, trappers and fishermen began settling in the section of Metairie known as Bucktown. By the early 1900s, Metairie had two public schools and two churches. The addition of a streetcar on Metairie Road prompted housing and business developments. In the 1920s, four pumping stations began draining the swamps and marshland. Gambling flourished in the 1920s and '30s, and more land was subdivided for new housing.

The opening of Airline Highway to New Orleans in 1940 created a market for new businesses and housing, but Metairie remained largely rural with many dairies. After Veterans Highway was completed in the 1950s, Metairie began to boom. Lakeside and Clearview shopping centers opened in the 1960s, as did new drive-in restaurants and theaters, bowling alleys, movie houses and much more. The I-10 carved a path though the community, displacing many homeowners and leaving motels and businesses along Airline Highway off the beaten path. By the end of the 1960s, the ancient Indian Mounds were bulldozed, but Fat City was coming alive.

The 1970s brought change when most of the drive-in restaurants shut down (some replaced by fast-food chain outlets), two theater venues closed, a bowling alley was turned into a nightclub and Metairie Road's krewes of Zeus and Helois changed their routes to ride along Vets.

Gone in the 1980s were Metairie Hospital, three more movie outlets, Beulah Ledner's beloved doberge cakes on Metairie Road, Sclafani's landmark restaurant on Causeway, the Pelican Bowl and the many Pik-A-Pak convenience stores. Fat City was losing its luster.

Food lovers lamented the closing of the House of Lee, Borden's creamery and Schwegmann's stores in the 1990s. Moviegoers felt the loss of Lakeside Theatre, Galleria 8 and Lakeside Cinema. Paradise Lanes, Metairie Hardware and the many Time-Saver stores closed. And the iconic rotating Walker-Roemer cow was removed from her perch along the interstate.

INTRODUCTION

After the turn of the twenty-first century, lost were Bucktown's "Fresh" Hardware and the community's homes, restaurants and boats along the Seventeenth Street Canal. Kenner Bowl and Tony Angelllo's closed. And Al Copeland's Christmas lights went out.

This book is arranged chronologically, not by years founded but by dates of loss. It is not a comprehensive history but a glimpse of places fondly remembered. There are likely mistakes here, but every effort was made to present information as accurately as possible.

The following shortened forms are used throughout the book: Airline (Airline Highway/Drive), Causeway (Causeway Boulevard), Clearview (Clearview Parkway), GNO (Greater New Orleans Area), S&WB (New Orleans Sewerage and Water Board), USACE (U.S. Army Corps of Engineers) and Vets (Veterans Memorial Highway/Boulevard). The following abbreviations are used in image captions: AC (author's collection), JPYR (*Jefferson Parish Yearly Review*), LDL (Louisiana Digital Library), LOC (Library of Congress) and TP (*Times-Picayune* newspaper).

1

EARLY TWENTIETH CENTURY

At the turn of the twentieth century, the Metairie Road area and Bucktown were primarily the only inhabited areas in Metairie. An 1899 survey tells us that there were eighty buildings along Metairie Road from the Seventeenth Street Canal to Causeway. Small farms and dairies occupied most of Metairie's dry land.

In 1908, the Bonnabel School in Bucktown replaced an older public school. In 1909, the Metairie Ridge School opened near what is now Haynes Academy and St. Catherine's Chapel was built in the woods at Labarre Road near Metairie Road—both still unpaved, as was Shrewsbury Road.

The debut of a streetcar on Metairie Road and the construction of St. Louis Church in Bucktown occurred in 1915. By 1917, some sections of Metairie Road were only twenty feet wide, despite the fact that, aside from River Road, it was the only route between New Orleans and Baton Rouge. A wooden bridge across the Seventeenth Street Canal allowed truck farmers to bring goods to market in New Orleans. At this time, Metairie Road was a segment of the Jefferson Highway, which ran from New Orleans to Winnepeg, Canada. (What we now know as Jefferson Highway did not open until 1928.)

A November 1, 1924 *Times-Picayune* advertisement for the new Country Club Gardens development described Metairie Road as "the ONLY OUTLET leading from the city to the WHOLE of NORTH AMERICA." On April 25, 1925, the Cedar telephone exchange office opened at 2728 Metairie Road at Gruner (a part of the building still exists).

In 1927, four pumps were online at canals to drain all of Metairie's swamps and marshes. That same year, the City of Metairie was incorporated and Louisiana Power and Light brought electrical service to Bucktown. The Jefferson Parish Police Jury opened the first section of Airline Highway, from Williams Boulevard to Shrewsbury Road, where it then continued along Metairie Road to the city. Airline Highway south of Metairie Road was not completed until 1928.

In the 1920s and '30s, gambling flourished in Jefferson Parish. Metairie Road was the home of some of the finest of these venues to be found anywhere.

Almost all of this is history now, with the exception of the pumps, which continue to keep Metairie land dry (most of the time).

Ridgeway Park (1914)

In 1914, "Urban Farms sites with city advantages" went on sale by the Vivian Land Company at 60 Ridgeway Park. The sites measured one hundred by two hundred feet. Early farms here included A.B Hagen's Squab Farm, Rault's White Orpington Chicken Farm and Hours' Registered Jersey Stock Farm. Vivian Street, off Metairie Road, now marks the entrance to this development, now filled with homes on much smaller lots.

Dairies (early 1900s–1920s)

On Metairie Road in 1910, John Bordes produced milk, cream and cream cheese. He lived at 124 Hyacinthe, near the pumping station. He continued in operation until at least 1943. Frank Bordes's dairy was also near the pumping station in 1912, at 503 Lake Avenue. He grazed his cows on the Seventeenth Street Canal levee.

On Labarre Road in the 1910s were the dairies of the Babin family and P.L. Palmsano. Schroeder's dairy began here around 1918. In 1919, J.F. Munsch was selling his cows and equipment—he was retiring from dairy farming to begin truck farming. Leontine and John Ernst started out in the 1920s; by the 1930s, John Ernst's dairy was at 3620 Airline. The Seivers family operated a dairy on Labarre in the 1920s at what would later be the Schwegmann's location.

On Metairie Road in 1918 were A.N. Rohli and S. Pailet, and in the 1920s, C. Rolling, Felix Bertucci and Louis Bertucci. By 1925, Louis was retiring and selling his property, cows, equipment and route. John A. Hummel operated two blocks west of the Frisco track across from the Thompson dairy. Hummel was selling his thirty-five cows, horses, bottles and more at an auction on August 16, 1923, in order to return to his prior occupation of contracting.

EARLY METAIRIE SUBDIVISIONS (1923)

The $70,000 public school under construction would become Metairie High. It replaced Metairie Ridge School, which opened in 1909. Today, it is Haynes Academy for Advanced Studies.

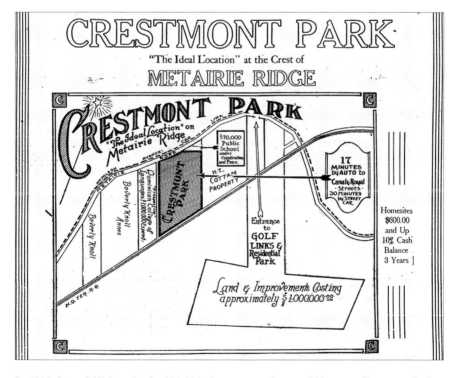

In 1908, Peter Stifft bought, for $20,000, the property that would become Crestmont Park. In 1923, he sold it for $100,000 to Guaranty Investment Company, which divided it into Glenwood, Hollywood, Rosewood and Ridgewood Drives. *TP*.

The tracts labeled Beverly Knoll, Beverly Knoll Annex and "Dominican College of Languages" was purchased by the Archdiocese of New Orleans around 1919 for about $42,000. In March 1920, Archbishop John William Shaw announced plans for a "Grand Seminary" to be constructed there. However, in May 1921, Shaw announced that the property was not large enough for this purpose. Notre Dame Seminary was built instead on Carrollton Avenue. A part of the Metairie property was sold on June 3, 1922, for $65,000. It became Beverly Knoll and Beverly Knoll Annex. The remainder was sold on November 9, 1925, for $141,000 to become Livingston Place.

Metairie Club Gardens, labeled as "Entrance to the Golf Links and Residential Park," was in the earliest stages of development. Formerly a part of the thirty-four-acre Ricks tract (384 feet on Metairie Road by 4,000 feet deep to the links), half of it was sold in 1926 to Service Realty/Alberto Vales. The other half was sold in 1928 to Charles Beresford Fox for $225,000. Plans called for a 100-foot-wide boulevard through the center with a beautiful neutral ground. The development would be named Farnham Place, which opened to the public on Sunday, April 28, 1929.

The Blue Line Streetcar, an extension of the New Orleans Napoleon Avenue line, ran along the lakeside of Metairie Road. The Cottam property did not open for development until 1946.

THE CITY OF METAIRIE RIDGE (1927–1928)

Some Metairie residents lobbied to remove gambling venues from their new upscale neighborhoods. Charles P. Aicklen, co-owner of Borden-Aicklen Auto Supply Company, was selected as chairman of the anti-gambling Metropolitan Municipal League, which circulated a petition for incorporation as a town disassociated from Jefferson Parish officials, who flagrantly turned a blind eye to violations of gaming and liquor laws.

The boundaries of the new town would be Shrewsbury Road, the Illinois Central Railroad tracks, the southern terminus of the Bonnabel Canal and the Orleans Parish line. This would include the Beverly Gardens, Metairie Inn, Victory Inn and Tranchina Night Club gambling houses as well as the Metairie Kennel Club and the De Limon Park greyhound tracks—all located on Metairie Road. These establishments contributed the vast majority of taxes collected in the area. Incorporation as a town would allow more tax

revenue for municipal improvements, but the prospect was a double-edged sword, with pro- and anti-gambling interests.

On June 15, 1927, Governor Oramel H. Simpson declared the incorporation of the City of Metairie Ridge. It would be headed by Aicklen as mayor, W.J. Dwyer as marshal, F.W. Bogel as clerk and E. Howard McCaleb as city attorney. Aicklen announced that he would shut down gambling houses by working with the new municipal courts.

In November 1928, the Supreme Court of Louisiana decided that the city had been illegally incorporated—of the 7,500 people who lived in the district, only 1,000 (not the 1,067 originally tallied) were registered voters whose signatures could carry weight on the petition, which required a two-thirds majority. A total of 649 voters signed the petition for a city charter.

Pro-gambling factions, which included Jefferson Parish district attorney Archie T. Higgens and Judge L. Robert Rivarde, had prevailed. In December 1928, the city was dissolved. Gambling remained active, although some of the largest operations (after the initial scare) moved to the new Jefferson Highway and River Road. In January 1929, taxes collected by the now-defunct city, amounting to $22,000, were turned over to Jefferson Parish.

Dairies (1930s)

In 1932 alone, Metairie dairies included those of Jos M. Harlem and Rene Kuhn on Metairie Road, Robert V. Adams on Metairie Road at Metairie Heights, Leo P. Forrester on Canal at Focis, Lee Grosch at 228 Papworth, Elinora J. Mackinroth at 344 Aris and Arthur C. Seruntine at 604 Canal. The Root family had several dairies. In 1932, Frank S. Root Jr. operated on Pomona at Orion (a block off Bonnabel and Veterans) at what was, until the 1940s, the end of the road. In the late 1930s, Aurora Avenue near what is now Veterans Highway was a dirt lane through brush which ended at the Melius Dairy. Beyond it, and the nearby Root Dairy, lay undeveloped land to the lake.[1] The Melius bungalow home at 515 Aurora still stands surrounded by newer homes. In Bucktown was Schaeffer's Dairy near Bonnabel and Victory Dairy near Hammond Highway, which was was sold in 1939.

ROYAL BLUE LINE STREETCAR (1915–1934)

On Sunday, July 18, 1915, the Napoleon Avenue streetcar line was extended from the Seventeenth Street Canal almost to Shrewsbury, running along the lakeside of Metairie Road. Due to the blue background color of its glass destination sign, it was known as the Royal Blue Line. The *Times-Picayune* captured a snapshot of the line's first foray into Metairie:

> *The cars pass the various real-estate subdivisions such as the Metairie Ridge Nursery, Metairie Heights, Bonnabel tract, Crestmont Park, etc. The whole region is high, partly wooded, and looks like a fine pasture country…at some points it actually shows hills. All along the loop there are nurseries, dairies, poultry farms, truck farms, etc.….Near the parish line there are numerous fine residences, and all along the tracks modern homes are being built.*[2]

The first fine residence, at the parish line, was the estate of George J. Friedrichs, who would build Metairie Club Gardens and Country Club on his property. Across the road was the Eastman farm and home. Nearby was

A 1927 view of Metairie Road's streetcar (*right*) by Charles L. Franck, from *Streetcars of New Orleans: 1835–1965* by Louis Hennick. *Maunsel White.*

school board superintendent J.C. Ellis's mansion as well as the fine residence of Harry Papworth, who fought to have the streetcar routed behind his home and business.

During the infamous 1929 streetcar strike, a Blue Line car was dynamited, resulting in damage to homes on Metairie Lawn. On the same day, an attempt to blow up the rails on the bridge over the Seventeenth Street Canal was unsuccessful.

Initiated by the New Orleans Railway and Light Company, the Blue Line was replaced by New Orleans Public Service buses on December 27, 1934, as per New Orleans Commission Council ordinance number 14187 c.c.s.

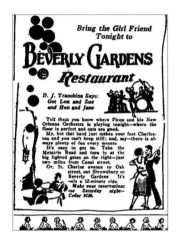

A 1926 advertisement for the Beverly Gardens on Metairie Road. *TP.*

BEVERLY GARDENS (1925–1935)

Often described as a "roadhouse" (a club located on a country road) and located at its current place-name at Metairie Road, this "restaurant," which was actually a plush gambling house, was opened in 1925 by Dominick Tranchina. Great jazz bands such as Papa Celestin's Original Tuxedo Jazz Orchestra and Armand Piron's New Orleans Orchestra were featured here.

In 1928, Governor Huey P. Long ordered forty National Guardsmen to confiscate its cash and equipment. It was soon back in business. In 1931, it was renamed Club Avalon. The club seemed to have gained some respectability when, in the 1930s, churches and clubs held meetings here and the American Legion followed up its 1932 parade with a dance at Club Avalon. It burned to the ground in June 1935.

VICTORY INN (EARLY 1920s–1936)

Dominick Tranchina also ran the Victory Inn (Ted Werner was also an owner), four blocks from his Beverly Gardens (with Fagot's Metairie Inn

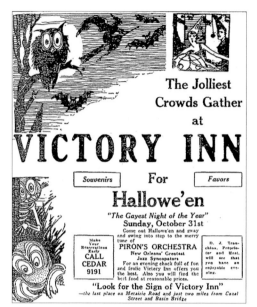

A 1926 advertisement. Piron's Orchestra was the house band for the Victory Inn during the 1920s. *TP.*

between the two). It was described as "A Bit of City in the Country" in a 1925 advertisement, followed in 1926 with "Yep! The Road Is Paved All the Way Now!," indicating that progress had been made in improving Metairie Road. Jazzman Peter Bocage said of the Victory Inn that it had a $100,000 gambling bankroll. On October 3, 1929, the contents and property (110 feet on Metairie Road and 148 feet on Vivian Street off Ridgeway Drive) were auctioned, but the place apparently remained in business until January 30, 1936, when the property was again auctioned and sold for $2,800. A Victory Inn later operated on Jefferson Highway.

First Carnival Association (1936)

The community's first organization dedicated to parading annually on the Sunday before Mardi Gras was the Metairie Carnival Association, which held its first (and apparently last) parade on Sunday, February 23, 1936, at 2:30 p.m. Beginning at the Pines Inn (a sandwich shop with carhop service and a tourist court on Airline at Shrewsbury/Metairie), it rolled along Metairie Road to Friedrichs Avenue, then to Northline, to Vincent and back to Metairie Road. The association, made up of business and civic leaders, was headed by officers James Aitken, Amos LeBlanc and Martin F. Garcia.

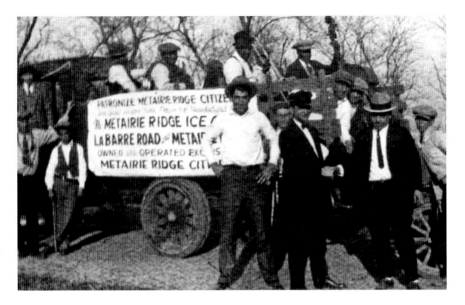

Participating in the Metairie Carnival Association Parade were Harry Mendelson's popular City Park band, a U.S. Marines Honor Guard, a U.S. Naval Reserve squadron, several floats, fifty autos, Boy Scout Troop 50 keeping order along the route and a dance band performing from a truck (probably pictured here). *LDL.*

ARTHUR JAMES'S MENAGERIE (1920S–1939)

In the late 1920s, in the new Metairie Terrace subdivision developed by James F. Turnbull at the end of the streetcar line, Arthur James began selling hunting dogs that he had trained. He operated out of his home at 3715 Bauvais Street under various names (Original Metairie Kennel, Metairie Terrace Animal Exchange, Metairie Farm Kennels, Arthur James Animal Exchange). Through the years, he bought and sold mink, flying squirrels, raccoons, chickens, deer, horses, mules, ponies, donkeys and boar. In 1929, he had a parrot from Africa. By 1935, he was selling a goat trained to pull a wagon. In 1936, there were pigs from California. In 1938 alone he had for sale one hundred white king pigeons, one hundred hounds from Tennessee and twenty monkeys. A burro from Jamaica was one of his last local sales, in 1939, before Mr. and Mrs. James moved to Baldwin Park, California. But they continued to advertise his acquisitions in the *Times-Picayune*. It is possible that the couple later moved back home, because in 1958, a chestnut mare, buggy and break cart was being sold at 3715 Bauvais.

1940s

INTRODUCTION

On August 26, 1940, a bridge built over the New Basin Canal directly connected Airline Highway to Tulane Avenue, thus creating a quick and easy route between Metairie and the city. Tulane Avenue had recently been widened to accommodate the expected traffic. There was now a direct route from Baton Rouge and beyond, through Metairie, to New Orleans.

Just two years before, officials were still requisitioning right-of-ways for the highway from Metairie landowners and awarding contracts for paving the road from Kenner to New Orleans. After all this work was complete, Airline Highway boomed with new restaurants, bars, dance halls, motel courts, drive-ins, service stations, bowling alleys and businesses.

In 1945, the number of homes doubled in Metairie, mostly within blocks on Metairie Road and Airline Highway, as well as in Bucktown. Even into the middle of the twentieth century, Metairie was largely rural—1945 ads offered "four fresh cows with calves and farm equipment—731 Carrollton St.," cows at 201 Zinnia, a bull at 52 Metairie Heights and a horse at 102 Oaklawn Drive.

The unnamed hurricane of 1947 wreaked havoc by breaching the Seventeenth Street Canal levee (on the Jefferson Parish side) and the inadequate lakefront levee. Floodwaters ran back as far as Metairie Road, and water as high as four feet stood for weeks, now trapped by what remained of the levees. Homes near the canal turned black as a result of noxious

fumes emitted from the stagnant water. Dairy cows, livestock, horses and poultry drowned, affecting the livelihood of those who owned them. Also of significance, 75 percent of the muskrat population was destroyed, a blow to the many who made their livings by trapping. Local authorities finally cut holes into the levee and into Hammond Highway to release water and used pumps to drain water back into canals. As a result of this catastrophe, in 1949, the Corps of Engineers rebuilt levees at the Seventeenth Street Canal and along ten miles of the lakeshore.

In the late 1940s, three bayous still existed: Laurier, Labarre and Bayou Tchoupitoulas (all flowing from the lake), as did Indian Beach near Bucktown.

Betz Tract (1839–1941)

German-born Nicholas Betz acquired land on both sides of Metairie Road in 1839 and built a home there shortly after. His son John Nicholas was born in 1847 on what is now Rosa Avenue (named for his wife). His grandson Theodore was born on the current Oaklawn Drive. In the early 1920s, Theodore had a nursery, selling his goods from a stand in the French Market. Betz land was used by the family and for truck farms and dairies until the 1920s.[3]

Hog Alley/Ingleside Heights (1921)

In 1921, Nicholas's son Peter Betz's land (on the north side of Metairie Road approximately between Focis and Nursery) was converted into Ingleside Heights. In an effort to improve its image, it was advertised as "A High-Class Subdivision for First-Class People."

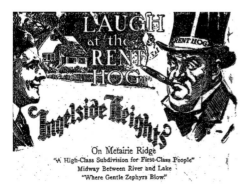

It is laughable to view this 1921 advertisement for the new subdivision proclaiming, "Laugh at the Rent Hog," because the land was known (and still is by many) as "Hog Alley." *TP.*

Metairie Kennel Club/Dog Racing Track (1925–1929)

The *Times-Picayune* reported that during the days leading to its formal opening, more than eight thousand men, women and children visited each day to take a look at the new track and facilities, which included electrical lighting installed by local electrician Charles Argo and the mechanical pacesetting rabbit "of the newest pattern." Argo predicted that "when the lights first go on local people in the vicinity would imagine there was some conflagration." The facility could reportedly accommodate four hundred greyhounds.

The first racing season called for seven events nightly with nine dogs per race and a Saturday matinee. Local businesses contributing trophy cups included the Monteleone Hotel and Loubat's Glassware Company. (Walter Loubat was a founding member of the club.) Groundskeeper C.G. Fitzgerald boasted that the club was "the finest in the country," but the venture was short-lived. In 1928, the state legislated anti–dog racing regulations, which were upheld by the U.S. Supreme Court in 1929.

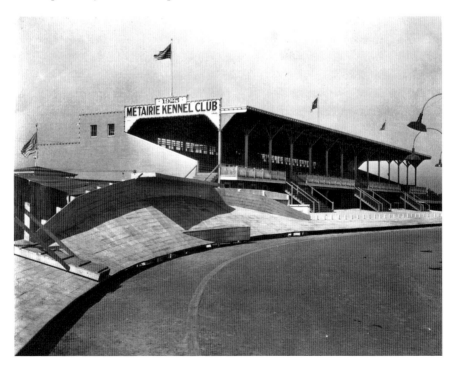

On September 29, 1925, the Metairie Kennel Club opened on the lake side of the Betz property between Rosa and Oaklawn. *LDL.*

Smith's/Metairie Oaks Driving Range (1931–1940)

In 1931, Smith's Golf Driving Range, with twenty-three tees, opened at the kennel club offering nighttime lighting, a glass-enclosed clubhouse from which to view the golfers and lessons from owners/golf pros Harry Turple and Wilfred Roux. An eighteen-hole putting course was added, as well as a nine-hole golf course. This later became the Metairie Oaks Golf Range and, in 1941, Oaklawn subdivision.

Oaklawn Subdivision

In 1941, Jesse R. Jones Corporation purchased thirty acres of the Betz tract (470 feet on Metairie Road, 26,000 feet deep) to develop the Oaklawn subdivision. He planned 138 homes across from Farnam Place and Oakridge Park; they were to be sold for between $4,800 and $8,000. This is now Oaklawn Drive.

Metairie Road at Labarre (early 1900s–1941)

On the riverside corner of Metairie Road at Labarre, across from Brennan's Cafe B Bistro, is a large, white, wooden eight-apartment house. Just down Labarre is a green Craftsman-style bungalow on a large lot that runs all the way back to Elvis Court. It was the home of Mrs. Ernest A. (Marie Irene Loup) Bertaut. The history of these properties goes back to Francois Pascalis de La Barre, a colonial official who was granted a river-to-lake tract in 1750. Over the years, the vast tract was sold and divided—but we'll jump to the twentieth century for a brief history of a small part of it in Old Metairie.

Labarre Road was home to a number of dairies owned by the Babin family in the 1910s. They also had a blacksmith shop here. The P.L. Palmsano dairy was also on Labarre Road, as was Schroeder's in 1918 and Leontine and John Ernst in the 1920s. P.J. Bordes had a dairy on the road in the 1930s and '40s.

In 1918, D.M. Montgomery had a home here (later Mrs. Bertaut's bungalow) and was selling chickens at the corner. The Pailet family's Metairie Ridge Ice Company was in the 300 block, employing sister Fannie and brothers Morris and Samuel.

In 1919, florist Alfred Louis Warriner bought the Montgomery home and property for $25,000 and opened Arundale Nursery. When Warriner moved his business to the old Poydras Plantation in Plaquemine Parish, he sold the property—111 feet on Metairie Road, 133 feet on Labarre—which included the cypress bungalow, a large barn, two chicken houses, a milk house, a water well and pecan, orange and shade trees to Herbert K. Smith in 1921.

In 1922, Paul Canone purchased the land (4.1 acres for $9,200), lived there and used it for his nursery business into the 1930s. Thousands of rose bushes were grown here. That same year, the first suburban home was built on the Canone tract by James F. Turnbull for P.J. Savoi for $4,300. In 1925, another was sold by Elvis Realty for $20,000; by 1926, the company was selling lots in Elvis Court shortly after paving on Metairie Road had been completed.

Mrs. Paul Canone died at age forty-nine in 1934. As a progressive woman (known professionally by her maiden name, Agnes Awcock), she began working at D.H. Holmes in 1914 and worked her way to become head of the advertising department and president of the New Orleans Advertising Club.

In 1937, Denis Loup bought the Canone Florist property with plans to live in the bungalow and sell or lease other parts. In 1941, all but the

Metairie Road at Labarre, 1947. The banner announces Sheriff Frank Clancy's political ticket. *Arvin F. Pell, LDL.*

home and apartments were sold—1,200 feet on Labarre and 450 feet near Metairie Road. It was divided into fifty-six building sites. In 1943, Ernest Bertaut and Marie Irene Loup were married and moved into her family home. She passed away on November 6, 2013, at the age of ninety-two. Where chickens, cows, horses and roses once flourished, the remainder of Labarre Road between the railroad tracks and Metairie Road is now filled with rental properties and homes, including the exclusive Savannah Ridge, developed in 1996.

FAGOT PROPERTY (1896–1940S)

Frank Fagot's Store (early 1900s–1934)

Frank Ernest Fagot came to reside in Metairie in 1896, having acquired some two hundred acres of land. By 1903, he owned and operated the first grocery in Metairie, located on property near his home bounded by Metairie Heights, Fagot Street and Metairie Road. The grocery housed the first post office in Metairie, an R.F.D. station operated by his wife, postmistress Florida Fagot, who was sued in 1906 by the U.S. government for diverting mail from New Orleans in order to profit by the cancellations

In 1910, Frank was appointed supervisor of Jefferson Parish roads. In 1912, he ran for the position of school director but was beaten by Alfred Bonnabel by eight votes. He was appointed parish commissioner of tax collection in 1913 and advocated for a streetcar on Metairie Road. In the 1920s, a modern Whip Freeze frozen custard stand operated on the Fagot property. Old-timers remembered a monkey tied to a tree near the store. On Saturday, May 26, 1934, an A&P grocery opened in Fagot's old store (after extensive renovations). The national chain leased the property and retained the post office.

Camp/Fort Fagot (1910–c. 1911)

Frank Fagot owned and operated Camp Fagot, also known as Fort Fagot (possibly an old component of Camp Parapet's Cavalier), where the U.S. Marine Corps erected a state-of-the-art rifle range. Frank and his wife entertained the marines in lavish style while hosting a 1910 shooting match and banquet that brought many spectators (including ladies) and ended

with fireworks. The venture was short-lived; it is likely that Camp Fagot was replaced by Metairie Heights:

Metairie Heights

In 1911, Fagot sold eighty-seven acres to Fidelity Land Company, which developed the first modern subdivision in Jefferson Parish. Named Metairie Heights, it consisted of one hundred lots, each 25 feet wide and 120 feet deep. Frank, a major stockholder, hoped to drum up business. He proclaimed that he would move his general merchandise store to a different location on the property and would add another story to the building.

Metairie Inn (1925–c. 1940)

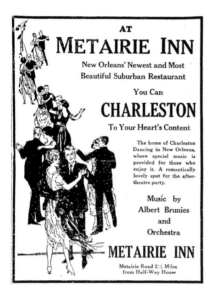

A 1926 *Times-Picayune* advertisement for Metairie Inn, the "home of Charleston Dancing." *TP.*

Atop the store, Fagot ran a gambling house widely known as the Metairie Inn. As early as 1912, allegations were passed that he was running an illegal bar out of his store, but local officials turned a blind eye to gambling. The place was openly advertised as a hot spot for a fashionable clientele who enjoyed jazz, dancing, dining and gaming there.

During the 1928 raid (which also hit the Beverly Gardens down the road), National Guardsmen confiscated loaded dice, $17,000 in cash and checks and gaming paraphernalia. Fagot said that he was across the lake at the time and had no idea that his son had rented the upstairs for gambling.

Later news reports tell us that a separate Metairie Inn, located at at 2315 Metairie Road on the Fagot property, outlived his grocery. In operation until the 1940s, it was used for dances, social gatherings and meetings. In 1934, Mrs. Fagot, working with the American Legion auxiliary, distributed Christmas toys there. A tea dance was given in 1935 for all military veterans by William F. Surgi, the Golden Rodent of the National Order of Trench Rats (an honorary organization

of the Disabled American Veterans of the World War). Metairie Inn was also the headquarters of James A. Noe (of WNOE radio) during his 1939 campaign for governor.

Frank Fagot died in September 1944 at his residence at 131 Metairie Heights (right down the street from his old store) at the age of eighty-five.

Eastman Property (1886–1945)

Ezekiel Webster Eastman acquired a large tract in 1886 of what had been the Hazeur Plantion, adjacent to the Seventeenth Street Canal fronting Metairie Road. Beginning in the late 1890s, the family began hosting community gatherings, dances, festivals, dog shows and more at what became known as Eastman Park. Daniel Webster Eastman died in 1940, and his wife, Ludervine Oesterle, passed away the following year. The park was in use until the mid-1940s.

When the property was sold in 1945 to Everett Marks and M. Compagno, neighbors suspected that they were planning a gambling/liquor establishment. The new owners retorted that their intentions were to build a movie theater, bowling alley and restaurant. None of that came to pass. Dr. Thomas William Melius Jr., who had worked with large animals at his parents' Melius Dairy, moved his practice, Metry Animal Hospital, which had been established in 1946 at 815 Metairie Road, to the front portion of the former Eastman property in 1952. He renamed it Metairie Small Animal Hospital. Thomas Melius, who was in practice with his brother Henry, retired in 2005 after Katrina. He passed away on May 19, 2013, at the age of ninety.

Persigo Dairy (1900s–1946)

In 1942, Charles Persigo, a dairyman since the early 1900s, ran an auction for his thirty-five-cow dairy at 1011 Metairie Road. Gus Persigo took over operation of the dairy. He sold it in 1946, stating in an auction advertisement that the property had been sold. This land is now East and West William David Parkways.

GENNARO FIELD (1928–1940S)

Charles Gennaro farmed at what is now the Causeway/Metairie Road area. He was a grocer, oyster dealer and owner of Gennaro's restaurant and bar on Metairie Road at Causeway. The establishment still bears his name. In 1928, he was granted a permit to construct a baseball and amusement park on his property at Harlem Avenue (now Causeway Boulevard) near the New Orleans Terminal Railroad tracks (this is now the intersection of Airline at Causeway). Local high schools and other teams played here until the 1940s. The twenty-five-acre park was managed by Charles's brother Sam, who also owned and operated Paradise Inn at 1516 Severn Avenue.

METRY SKATING RINK (LATE 1940S)

Ward W. Ward and Stanwix Mayfield operated Metry Skating Rink at 700 Metairie Road at Focis. Lessons were available, taught by professional skater Arthur Walace. This would later become the location of Mike Persia Chevrolet, Tri-Cities Renault, Bryan Chevrolet, Mike Persia (again), Gary Motor Company, Circle Motors, Terry Motor Company, Dixie Camper Sales, Apache Campers, Dixie Campers, Crest Sports & Imports, Barney's Auto Sales, Parr's Place Mexican Market and, finally, the Old Metairie Village Shopping Center (which encompasses the entire 700–900 block of Metairie Road). The shopping center once housed much-missed local favorites McKenzie's and K&B.

EDDY TRACT (SOLD 1949)

In 1924, Robert S. Eddy purchased the Jefferson Park thoroughbred track (now Azalea Gardens subdivision). In 1926, he was busy supervising the readying of a road from Metairie Road to the racecourse he owned along with Robert S. Maestri. The two men also had controlling interest in the New Orleans Fair Grounds. In addition, Eddy was a real estate investor who owned the fine home at 5120 St. Charles Avenue, which would become the Milton H. Latter Memorial Library.

In 1932, for $600,000, he bought the F. and P. Maestri Furniture Company (one of the city's largest, co-owned by second-generation proprietor Robert S., who would become mayor of New Orleans in 1936). Located at 140 North Rampart, F. and P. Furniture then became Eddy Furniture Company and would be managed by Eddy and his three sons. Eddy had a long-range vision—two of his boys were still in school, but by 1938, one of them, Fergus Hathorn ("F.H."), was the company president.

F.H. was an avid golfer, equestrian and breeder of horses on his three-hundred-acre estate along Airline Highway running three miles back to the lake. His wife, Willamene, was an accomplished equestrian, and they both supported the efforts of the first Episcopal parish in Jefferson.

In 1946, Reverend David C. Colony was appointed rector of St. Martin's Episcopal, which had no church and held services at Metairie High School. What follows is his story, told in a full-page advertisement published in the *Times-Picayune* on February 15, 1951.

In May 1946, eleven people attended his service at Metairie High during a massive storm while the land purchased for their church at Atherton and Metairie Road was an underdeveloped tract of weeds and woods. By February 1947, the new church/school was built, minus pews, but used for an Ash Wednesday First Communion. The little school had twenty-five kindergarten students and the parish was in debt. In August of that year Oscar E. "O.E" Haring, car dealer and financier stepped forward with a donation of $20,000 from his educational and religious charitable foundation. In September 1948 the "Haring Building" opened allowing for four grades. With continuing support from Haring and parishioners, by 1949 the church was enlarged, air-conditioned, and furnished while a second classroom building opened for the school which now had two kindergartens and grades one through four.

In 1949, F.H. Eddy agreed to sell his Green Acres Farm (which had been readied for subdivision as early as 1941) including his mansion, a second house, three barns and 260 acres of undeveloped land for $175,000 to the church parish. He allowed for clear title of forty front acres with a $17,000 down payment collected from parishioners and school parents within one week. The parish used this as a building site, not only for a new school but for new homes and within one month $242,000 worth of property had been sold. By January 1950 the parish secured full title to the complete tract and by September ten new school buildings had been constructed to allow for six hundred students in grades K-12 at a cost of $500,000.

Early advertisements for the housing development welcomed parents to "St. Martin's Green Acres," where children residing within would have first preference for entering the school and families would be eligible to use the school's recreational facilities—the partially built gym and the planned pool, tennis courts, golf course and stadium. A shopping center was also said to be planned, and the homesites were said to be at a nineteen-foot elevation. Lots were initially offered from $1,500 to $1,800 but were later dropped to from $800 to $900. The first two streets developed were Green Acres and Haring Road. The next were Colony and Marguerite. Plans were in the works for the development to stretch to the lake with twelve hundred homes. And according to Reverend Colony, by February 1951, the church had grown to a membership of five hundred families.

Colony led a colorful life. Born in Lithuania, he served in the British army during World War I but had come to the United States as a boy. During World War II, he served in the U.S. Army as a chaplain. He was headmaster of St. Martin from its inception until 1951, when he left the ministry after a conflict with his bishop. He was chairman of the board of the Green Acres Corporation and the first president of the East Jefferson Development Association. In 1959, he ran for sheriff of Jefferson Parish on a pro-gambling platform that advocated placing gambling taxes in a trust to be used for low-interest college loans and first-home down payments. Colony died in 1974 at the age of seventy-five.

Green Acres Road/Court and Haring Road/Court still run from Airline to the lake, and St. Martin Street between Avron and West Esplanade hearkens back to Reverend Colony's efforts. Saint Martin's school now stretches from Airline to West Metairie between Green Acres and Haring Roads. The old Eddy mansion at 5200 Airline is used as an administration building. The short Eddy Road, between Marguerite and Green Acres Roads, reminds us of the prior history of this development.

3

1950s

INTRODUCTION

Many new subdivisions were created in the 1950s, most of them after the opening of Veterans Highway. Just as Airline Highway had made the area along Metairie's southern border accessible, Veterans brought a boom through its center.

In 1950, two new movie venues opened: Crescent Airline Drive-In and the Patio Theater. Schwegmann's located its first Metairie grocery on Airline at Labarre in 1951. The next year, Metairie Playground opened. The Do Drive-In arrived in 1953.

Metairie's first Frostop and Time-Saver store opened in 1954. East Jefferson High School opened the following year. Crescent Airline Shopping Center opened in 1956, as did the two-lane Lake Pontchartrain Causeway bridge, allowing easy transit to and from the north shore. In 1957, a new parish office building was erected on Metairie Road. The Krewes of Zeus and Helois made their debuts in 1958, as did Sclafani's restaurant.

Jefferson Parish voters approved the construction of twelve new schools in 1959. Also that year, Jefferson Downs opened off Vets and Metairie's first Putt-Putt course opened on Causeway as the I-10 was being constructed. Along Vets in 1959, Paradise Lanes, the House of Lee and Meydrich's food store opened. And sadly, the ancient "Indian Mounds" near the lake were destroyed by a housing developer.

COTTAM TRACT (1920s–1952)

Businessman H.T. Cottam acquired eighty acres of property adjoining Metairie Club Garden and Country Club for $80,000. He built a home, farmed some of the land and, in 1938, donated fifty acres and $100,000 to Charity Hospital for the construction of a convalescent home. After neighbors protested that their properties would be depreciated by such an endeavor, the police jury prohibited its construction and the property reverted back to the Cottam estate.

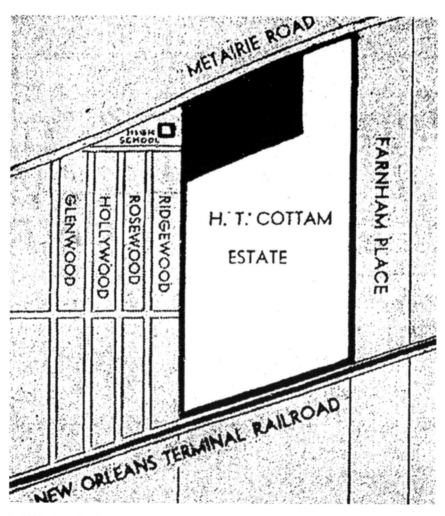

In 1938, the police jury expropriated 9.14 acres (represented in black) to expand the adjoining Metairie High School campus for the addition of twelve classrooms, a gym and athletic fields. *TP.*

COTTAM PARK SUBDIVISION

The remainder of this property, 380 feet fronting Metairie Road by 1,356 feet deep, became the Cottom Park subdivision. It opened for sales in 1946.

MAPLE RIDGE SUBDIVISION

In 1942, twenty-eight acres of Cottam property were divided into the $1 million, 152-home Maple Ridge subdivision, built under a World War II housing program that allowed war-industry employees first preference as renters ($45–$50/month) or buyers. The average home price was $4,750 for the two- and three-bedroom homes built in an existing maple grove.

Even by 1956, some of Cottam Tract was still undeveloped. Members of Maunsel White's family pose for a shot on Crestmont Drive near what they called the "Cottam Woods." *Maunsel White.*

METAIRIE PLAYGROUND

The property adjacent to Metairie High School was used as a public playground in 1945, but in 1952, Metairie Playground (now Pontiff Park) opened on the remainder of the old Cottam tract.

SUBURBAN BOWLING ALLEY (1940–1956)

Georgia Stone and Howard Sheldon are instructing women in the ladylike art of bowling, which everyone says is a grand summer sport. At Suburban Bowling Alleys, 3380 Air-Line Highway, there are dressing rooms and lockers for women, even special alleys for them, and a counter of bowling shoes, bags and accessories for sale, so the girls may feel correctly togged out.
—*Up and Down the Street by the "Want-Ad Reporter,"* Times-Picayune, *April 2, 1941*

Sanctioned league bowling came to New Orleans in 1938. Metairie's first bowling alley, located at 3380 Airline at Shrewsbury, opened in 1940 with nine lanes. But owners Lynn Domingue and Vernon Dupepe (who also owned the nearby Aereon Theater) found room enough for billiards tables. In 1941, Suburban participated in the citywide Brunswick $50,000 Bowling Carnival. In 1945, the metro area's first sanctioned 300 game was bowled here by Bill Thompson.

Times-Picayune classified ads for "colored" pin boys were common in the 1940s and '50s. Lloyd Price, who grew up to become an entertainer and entrepreneur, was one of them. He recalled of his days at the Suburban when he was sixteen: "Every Saturday night Blacks were allowed to bowl. It was eleven cents a line. I would take home broken pins and balls and try to bowl at home in the mud."[4]

In 1950, Horace C. Duke bought the business and served as its operator, advertising its reopening for October 7. But the place closed down in 1956. Its lanes were used to build Fazzio's alleys at 929 St. Charles Avenue. Jefferson Lumber opened on the Suburban property in 1957.

By 1941, three more lanes were added to the Suburban Bowling Alley, which would have been dwarfed by later suburban bowling centers. *TP.*

CRESCENT DRIVE-IN THEATRE (1950–1955)

A March 30, 1950 *Times-Picayune* article reported the impending opening of Metairie's second drive-in. (Airline Drive-In had opened just months before in January.) The Crescent was next door to the Borden dairy plant. The $250,000 project was developed by Laten Inc., co-owned by local realtor Harry Latter. Just west of Ridgewood Drive, it accommodated 600 cars and parking for an additional 250 for folks who opted to enjoy a "country-club type patio with lawn chairs, gliders, and tables" designed for them or for pedestrians using the Atherton Drive entrance.

It was built on the former Geisenheimer tract. The family had owned the land between Airline Highway, Labarre Road, Borden's and the area due south of Manley Avenue since the early 1900s. One of the largest tracts on the highway, it was sold in 1950 by Latter and Blum for commercial development for $365,000. On another section of this land, one year later, Schwegmann Brothers Giant Super Market was built.

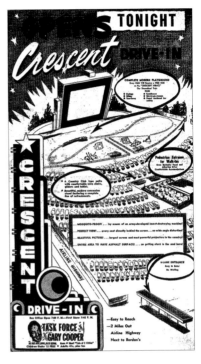

Crescent Drive-In's opening night, July 27, 1950. *TP.*

The drive-in opened on July 27, 1950. The advertisement announcing it stated: "One-half million dollar amusement center…mosquito proof!—by means of an army-developed insect-destroying machine!" Children were admitted free and could enjoy the enclosed playground as well as a ride on the streamlined "Crescent Hiball" train. A six-lane entrance allowed for "no waiting" to proceed along the "asphalt surface!...no getting stuck in the mud here!" *Task Force*, starring Gary Cooper, was the opening-night film, projected on the "Largest Screen" and "most Powerful Projectors in the Country!" All of the attractions could be had for a mere forty-one cents plus tax.

Not to be confused with Airline Shopping Center, which had opened at 4111 Carrollton near Tulane in 1941, the Crescent Airline strip mall opened in the drive-in location in 1956. The Maison Blanche Department store was

a major draw. MB's next-door neighbor was Goldring's, another Canal Street store that, for the first time, expanded with a location in Metairie. Other stores in the center included a Walgreens, Hobbyville, the Harem cocktail lounge, Imperial East Gifts, Thom McAn shoes, My Shop, Mayfair of New Orleans, Baker's and National Shirt Shop.

Up front in a separate older building was a McKenzie's Pastry Shoppe, Toy Land, J.D. Construction Company and a Brunswick bowling supply outlet that later housed a Buck Forty-Nine Restaurant. McKenzie's refurbished its store for the opening of the big shopping center, offering self-service for quick shopping. In 1971, Crescent Airline Shopping Center was renovated and renamed Airline Village. Now Celebration Church, Dollar General and Tuesday Morning, among others, occupy the old property.

VETERANS MEMORIAL HIGHWAY (1954)

After the swamps and marshes were drained, moss-laced cypresses were cut through to create Metairie's newest highway, allowing for development all the way to Kenner. The thoroughfare was initially only two roads containing two lanes each. Design plans that were never realized included thirty-foot-wide service roads on both sides separated from the highway by eighteen-foot-wide medians with sidewalks on either side.

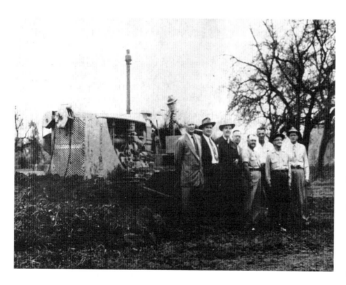

On February 18, 1954, ground was broken for Veterans Highway. John J. Holtgrove, president of the Jefferson Parish Police Jury, mans a tractor while other officials and workers look on. *JPYR.*

WIGWAM VILLAGE (1940–1954)

Proprietors F.O. Rudesill, Pierre H. LeBlanc and his wife, Eunice L. LeBlanc, welcomed all to the country's only two-story wigwam, which housed an à la carte restaurant specializing in Burgundy Burgers and cold sliced chili sandwiches, and to the lovely bar, or to spend a night or more in one of the ten sleeper wigwams. There was also an Esso service station and a souvenir shop.

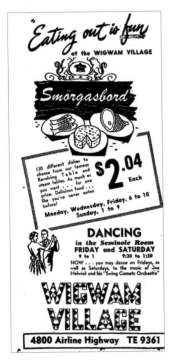

It was one of seven Wigwam Motels designed by Frank Redford. The others were in Cave City, Kentucky (two motel villages); in Birmingham, Alabama; near Orlando, Florida; in Holbrook, Arizona; and in San Bernadino, California. Metairie's village was a popular venue for club meetings and other functions (including the New Orleans Chamber of Commerce and the League of

Left: A 1950 advertisement for Wigwam Village's restaurant. For a mere $2.04, the smorgasbord allowed for eating "as much as you want" of the 130 dishes of "food you've never seen before" from the "famous Revolving Table." Patrons could dance to Joe Helwick and his Swing Comets Orchestra in the Seminole Room. *TP.*

Below: While the Garden of Memories cemetery was preparing to open in 1940, Wigwam Village No. 3 set up shop across the street at 4801 Airline, one block east of Transcontinental. *Maunsel White.*

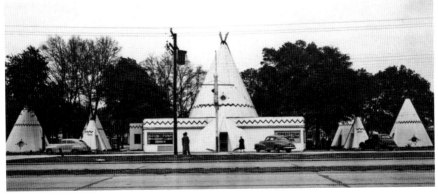

Women Voters). It closed in 1954 and was demolished in 1955 to make way for a shopping center that never materialized.

In 1958, the nearby $1.2 million, one-hundred-room Versaille Motor Hotel at 4841–49 Airline was built by Wigwam Inc., which was headed by Gerald Michael Smith and George J. Springer. By 1960, it had become the first of the chain of Candlelight Inns.

ALAMO PLAZA (1945–1956)

The Alamo Plaza Tourist Court was demolished to make way for the Causeway/Airline overpass/underpass and the new East Jefferson Parish office building and the East Jefferson Community Health Center, which opened in 1963. Built at a cost of $510,000, the health center contained twenty-one thousand square feet, including a mental health center and auditorium.

SOUTHERN TAVERN (1945–1956)

Located between Causeway and Severn/Shewsbury at 3375 Airline, the Southern Tavern's grand opening was held on Saturday, January 5, 1945. It was a popular restaurant and bar. It was probably scheduled for demolition along with the Alamo Plaza, and a 1956 auction offered all its equipment, including forty-five booths, a well-stocked kitchen and a recently purchased $4,000 neon "Southern Tavern" sign. However, that same year, it was remodeled for use as East Jefferson Parish administrative offices and jail.

ST. REGIS RESTAURANT AND COCKTAIL LOUNGE (1940–1956)

Next door to the Suburban Bowling Alley, restaurateur Edward H. Seiler opened a Metairie location of his longtime Royal Street restaurant at 3500 Airline at the intersection of Shrewsbury on Saturday, December 21, 1940. With two dance floors, a block of free parking, air conditioning,

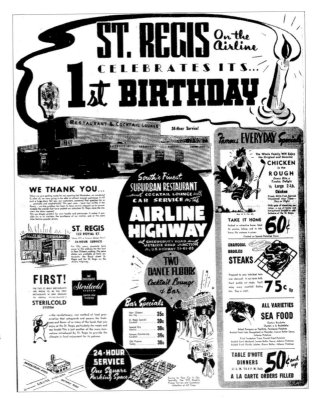

Right: A December 18, 1941 advertisement for St. Regis Restaurant and Cocktail Lounge. Older folks may remember the revolving neon sign atop the building featuring a golf-playing rooster with a broken club. *TP*.

Below: The Texas Motel, 2012. *Infrogmation*.

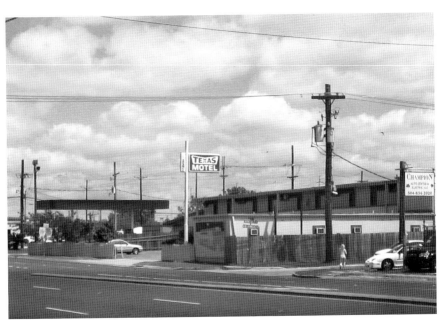

reasonable prices, slot machines and curb service, the twenty-four-hour bar and restaurant appealed to all ages. The cocktail lounge was a favorite of local political figures. The restaurant specialized in charcoal grilled steaks, "Shrimp in Shorts" (peeled with the tail end intact) and "Chicken in the Rough" (disjointed fried chicken served with honey and buttered biscuits).

In 1941, a large soda fountain was added, and curb service was provided by "Soldierettes and Sailorettes" attired in military-style uniforms hopping to cars "double-quicktime." In 1949, a roof garden was added, and the likes of "Red" Schroeder and Al Hirt entertained there. In 1956, former pro boxer and state representative James Beeson took over for a brief period before selling the place in 1957 when it operated as the Friendship House Motel, Restaurant and Lounge. In 1959, the restaurant, doing business as the Sirloin Room, was destroyed in a massive fiery explosion set by arsonists. The original motel building still stands, now operating as the Texas Motel.

Metairie/Metry Theater (1926–1950s)

On January 5, 1926, Eli T. Watson opened the Metairie Theatre on Metairie Road between Frisco and Aris Avenues near the railroad crossing. In 1927, he reigned as Rex, King of Carnival, and a year later he opened the first bridge across Lake Pontchartrain. At a cost of $5 million, it was later named the Watson-Williams Bridge for his company of investment bankers headed by him and his partner, George Williams. Most locals now call it the "five-mile bridge."

Watson's theater featured stage shows and motion pictures and was used for political meetings and rallies, including meetings of the Eighth Ward Dumestre Club in support of Alexis Casimir Dumestre's run for police jurist. A 1928 *Times-Picayune* article described Dumestre as the "Owner and manager of the show," which was holding a benefit with proceeds supporting the neighborhood Boy Scout troop. In 1929, meetings were held here to discuss a proposed water plant, exorbitant gas rates, better streetcar service, lower telephone rates and improved roads in what would become known as Old Metairie.

C.E. Strause and H.A. Johnson took over management of the theater. They added heating and reopened it on April 29, 1930, touting an RCA Photophone to show *The Cock-Eyed World*, starring Victor McLaglen, Lily Damata and Edmund Lowe.

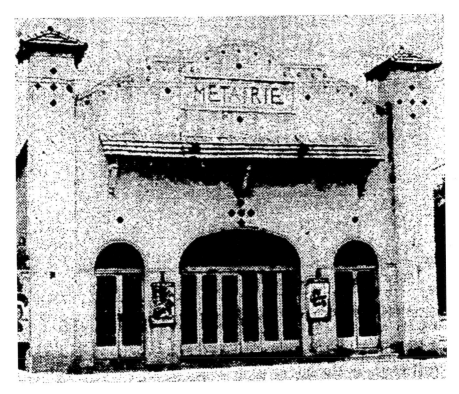

This photo of the Metairie Theater is from a June 6, 1937 article announcing that "various special features for the comfort of the patrons have been introduced and an effort has been made to have the theater one of the most artistic in the United Chain." *TP.*

In 1932, C.F. Bullard leased the building, and Joseph Gruner became the manager. A highlight of that year was a rally on February 21 at De Limon Park for the Eighth Ward Democratic Club with motion pictures run before and after the speaker presentations. It culminated with Dumestre's speech from the theater, broadcast on WTBO radio at 6:30 p.m. Meetings and benefit shows continued here, and in 1935, the theater was used to distribute tax exception forms.

The building was sold in 1937 to the United Theatres chain. The theater reopened the evening of June 11, 1937, with interior and exterior renovations along with updated equipment, a new screen and sloped floors. An ad announced, "Rogers & Astaire to open new Metry Theater with Shall We Dance with 8 fresh songs—one of the most attractive playhouses in the City—6:30 Admission 10 cents & 20 cents."

On June 30, 1940, Miss New Orleans candidates were chosen at all local United theaters, including the Metry. By 1952, the theater was unused but made front-page headlines: "Jefferson Boys Nazi Club Bared—Nazi Storm Trooper Club." Nine teenage boys were arrested for allegedly planning to bomb it. It has been alleged that Gordon Novel, later accused by Jim Garrison as a conspirator in the Kennedy assassination, was one of these boys.

GROTTO OF CHRIST'S PASSION (1930S–1950S)

According to the 1938 Federal Writers' Project *New Orleans City Guide*, Father Leo S. Jarysch funded a grotto built by parishioners in the front yard of the old rectory of St. Catherine of Sienna Church (before the current church was built). Constructed with broken, discarded concrete from street repairs, it was graced with life-sized statues depicting Christ's Agony in the Garden, trial, crucifixion and burial. The good father, as of 1938, had planned additional Stations of the Cross as well as St. Peter's denial of Christ and a large statue of the resurrection. Father Jarysch served at St. Catherine from 1925 through 1939, when he was transferred to St. Joseph in Gretna. Time and progress apparently took their toll on the grotto—it was destroyed, likely when the new church was built in 1957. Folks who remember it tell us that it was dark, damp and sometimes a bit scary. A statue of Mary, said to be from the grotto, is still on the parish grounds.

DREAMLAND (1946–1959)

Near the Alamo Plaza, at the current location of the Jefferson Parish Health Center at 219 North Causeway, was the Dreamland Ballroom (2319 Harlem Avenue). Opening in 1946, when it was accessible from Airline Highway, the massive hall could seat twelve hundred and offered food and drink and dancing.

In 1947, it was renamed the Plaza Club. By 1948, it was billed as "Tregle's Dreamland," where nothing cost more than thirty-five cents and there was nightly dancing to a live orchestra (often Dutch Andrus with Music for Moderns) in the "South's Largest Nightclub." Lawrence Tregle also catered

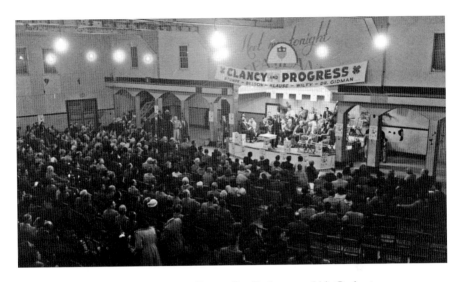

Louis Prima played at Dreamland Ballroom, Pat Barberot and his Orchestra were regulars and Frank Clancy celebrated his twenty-fifth year as sheriff to the tunes of Governor Jimmie Davis and His Hillbilly Orchestra. Clancy is pictured on stage in 1952. Life *magazine*.

to the sorority and fraternity set, as well as hosting weddings, political rallies and club and organizational meetings. The business's oft-used slogan, "Meet me tonight in DREAMLAND," fell out of use when the venue was used for agricultural fairs and religious revivals.

In 1959, it became Ray's Roller Pavilion, operated by Mr. and Mrs. Raymond Durr. The Durrs also owned the Roller Pavilion at 2100 Williams Boulevard in Kenner, as well as Ray's Rollerama and Big Eight Wheels Skating Rink in Jefferson.

4

1960s

INTRODUCTION

Jefferson Parish's population quadrupled between 1940 and 1960 (from 50,427 to 208,769), but many areas of Metairie were still undeveloped. When Lakeside Shopping Center opened in 1960, there were no traffic lights on Vets between Causeway and Haring Road (two blocks west of Transcontinental). The Kenner and Joy bowling alleys opened that year.

A new East End School opened in Bucktown in 1961, as did Pelican bowling lanes and the first Pik-A-Pak convenience store.

In 1962, Veterans Highway had six traffic lights—the last, at David Drive, was dedicated in a ceremony in March, where councilmen George Ackel and Vial Blanke announced plans for the construction to begin on July 1 of two additional highway lanes between there and Williams Boulevard. Two schools (T.H. Harris and Riverdale for girls) opened while plans were being made for a second all-girl high. The first Hoppers opened in Metairie, as did the Airline Bowl and Studio Arms apartment complex.

Plans were in the works for playgrounds at Airline Park, Neyrey Park and Bissonet-Maned Downs, as well as a community center at Bunche Village. The Charles A. Wagner Library was under construction in Bissonet, and Maggie and Smitty's Crabnett opened in East End.

In 1964, the I-10 from the Pontchartrain Expressway to Williams Boulevard was under construction. Lakeside Hospital opened on Vets and Bonnabel, and the massive Butterly Terrace Apartments were built. Jefferson Downs burned down.

Two movie venues opened in 1965, Westgate Drive-In and Lakeside Theatre. Additions in 1967 included the Saints' practice field, the Lobby Library and Lakeside Cinema. Metairie High's main building was demolished in 1968, but Woolco and the Sena Mall opened.

The second span of the causeway opened in 1969, and so did Clearview Shopping Center (on August 6). Occupying thirty-one acres with 400,000 square feet of floor space, it was Metairie's first new enclosed mall. It is still there, but gone are the K&B, A&G Cafeteria and the three-story Maison Blanche store, which was replaced by Target in 2002.

LAKESIDE SHOPPING CENTER OPENS AS AN UNENCLOSED MALL (1960)

Lakeside opened at Vets and Causeway on May 24, 1960. Considered a regional shopping center, Lakeside was built in the then-modern mall style with a vehicle-free, open-air, pedestrian-only central court. It offered the largest parking facilities in the South, with a 415,000-square-foot parking lot designed to hold five thousand cars.

Built on fifty acres (of what was good hunting ground), the eight-hundred-by sixty-foot structure was designed to contain thirty stores as well as a 150-seat auditorium. Covered walkways protected shoppers from the elements, and every store had two egresses, one from the mall courtyard and the other to the parking lot. In 1968, the mall was enclosed.

The modernistic lights at Lakeside were the talk of the day and could be seen from miles away. Their design, the first of its kind in the United States, included four 150-foot-tall steel pylons, each holding forty-seven fluorescent lights producing a total of seventy-two thousand watts of power. The lights have been replaced. Another innovation at Lakeside was the first "television depository system" in the GNO at the First National Bank of Jefferson: a drive-up banking window.

Of course, the shopping center remains, much enlarged and improved, but stores lost since its opening include the classic New Orleans stores D.H. Holmes, Godchaux's, Kreeger's, Steven's, Werlein's Music, Hausemann's Jewelry and Halpern's Fabrics, which, for the first time, opened suburban locations. The mall's one-stop-shopping experience included the now-defunct T.G.&Y., Lerner's, S.S. Kresge, Turntable Records, Jean's Paris Hats, Village Lady, Danny's Men and Boys Wear, Holloway House, The

Magi, Dino's Studios, Smarty Pants, Orange Julius and the Fun Arcade. On Lakeside's grounds were the now-defunct Western Auto, Cinemas I and II theaters and a Super Slide.

ZESTO (LATE 1950S–EARLY 1960S)

When drive-in dining was the rage, a Zesto franchise of the national chain popped up at 3329 Metairie Road between Athania Parkway and Gennaro Place. Operated by John Randazza (who would later own the Black and Gold Shop as well as Kate Latter's pralines), it had gaming machines, making it popular with folks old and young. It also had Zest-O-Mat frozen custard machines and a full soda fountain. By 1961, it had become the Pancake Palace and, in 1963, the Metro Diner. All the while, the businesses shared the property with the Metairie Professional Building which still exists today.

BARLON PLAZA SHOPPING CENTER (1961)

This center opened in the 7100 block of Vets at David Drive on a 300,000-square-foot piece of property with a 400-foot highway frontage and a 700-foot depth, nearly bordering the Bissonet Plaza subdivision. With an eight-hundred-car parking lot, it was obviously "designed to serve the families in subdivisions along the highway," as noted in the *Times-Picayune*.

As an indication of how undeveloped Veterans Highway was at the time, when the A&P opened here with thirteen checkout counters on February 2, 1961, shoppers were directed to find it "near Jefferson Downs"—a half mile away. A store officer noted that this establishment was built to serve the "ever-expanding population" in the area. The Morgan and Lindsey variety store opened soon after, on March 23, with advertising boasting of ten thousand items in thirty departments (apparently very small departments) with "Complete Self-Service!" At the grand opening, a drawing was held every hour (winner need not be present) featuring a grand prize—a Decca stereo valued at $59.95. Other prizes would make a modern-day parent grimace—a birdcage and canary or an aquarium and fish. Prizes also included an animated TV light, a telephone table and an ashtray with a planter.

The old building, still there, was once the home of McKenzie's. A Shoe Town and Katz & Besthoff once existed in an additional building. The K&B is now a Walgreens. Big Lots takes up most of the original strip.

MAGNOLIA PARK/JEFFERSON DOWNS (1954–1965)

In 1954, members of the Green Acres Civic Club opposed a planned harness-racing course in their neighborhood, filed a suit and parked cars to block access to the construction site—to no avail. Felix Bonura had leased 424 acres with a ten-year lease, and the Louisiana State Racing Commission granted him a permit for night racing at Magnolia Park. Bonura served as the president of the multimillion-dollar pari-mutuel track that opened in 1954 on Frank J. Clancy Boulevard (now Downs Boulevard) on what was a portion of what was originally the La Freniere concession. The

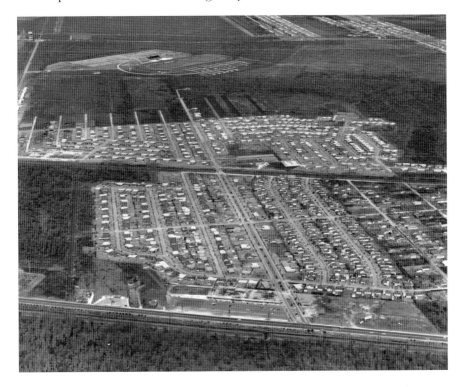

Jefferson Downs as seen in 1959. Note the water tower at Vets and David Drive in the upper-left corner. Airline Highway runs across the bottom. *Maunsel White.*

syndicate built a $100,000 road (David Drive) from Airline Highway to the track, where there was parking for five thousand vehicles. The facility had seating for 2,500 in the grandstand and 600 in the dining area and could accommodate more than 10,000 spectators on the grounds. Barns provided spaces for six hundred horses on the 227-acre track. The remaining 200 acres was later used for housing development. The harness-racing season ran from September to Thanksgiving Day (when the New Orleans Fairgrounds opened each year).

Magnolia Park was rebuilt in 1959 and converted into Jefferson Downs, a thoroughbred racing course with nighttime races. It closed in 1965 after severe damage from Hurricane Betsy. On Halloween evening, 1967, a fire resulted in a total loss of what remained of the abandoned facility. Jefferson Parish acquired the property and broke ground in 1977 for Lafreniere Park, which was dedicated and opened in 1982.

JOY'S BOWLING CENTER (1960–1967)

Joy Houck opened the forty-lane Joy's Bowling Center at the location of his old Patio Theater (3939 Airline) in 1960. Its run was short; in 1967, Houck converted the property back to a theater, the Joy's Panorama. An Auto Zone currently occupies the property.

DAIRIES (1960S)

As housing developments moved in, many Metairie dairies relocated to the north shore. However, in the 1960s, several dairies remained viable, including John H. Howell's Jones Dairy in Bridgedale (c. 1949–1964), Muller's Sanitary Dairy (c. 1949–1966) and Schaeffer's Dairy near Bonnabel.

From the 1940s through the mid-1960s, Bucktown's Lapuyade brothers owned the Western Star (300 Met Lawn near Bonnabel) and Eastern Star (Lake Avenue) dairies. The Patrick stables were located near the Bonnabel Boat Launch and were later owned by George Buchert. An eight-foot gate with horseshoes mounted on it was wrecked by Hurricane Katrina in 2005 and later demolished. Relative Earl Patrick ran a creamery near Hesper.

BY LUCAS J. SCHIRO, AUCTIONEER

AUCTION
COWS--COWS
Thurs., July 9, 1942, 1 P. M.
RAIN OR SHINE

Property of E. Adema, Known as ETTA DAIRY, East End Jefferson Parish, Hammond Highway, Next t Pontchartrain Dairy of S. DeDebrant. Go down New Basin turn down Hammond Highway 3 miles.

25 Cows—Holsteins, Guernseys and Jerseys; fresh milkers and heavy springer. 12 heifers. 1 Holstein bull.

One Kelvinator dry box. 80-gallon capacity; 1 bottle capper and filler; milk cooler bottle washer; cases and bottles; milk cans and all other articles appertaining to first class dairy.

This is a nice lot of cows. Dairymen and others in need of milk will do well buy ing here. Producing 45 gallons milk per day, largest purchaser gets the route.

TERMS: 90 days with approved endorser. Interest at 8%. Please have you endorser present.

L. J. SCHIRO, Auctioneer

OFFICE: SCHIRO STOCK FARM; 5000 Jefferson Highway, CEdar 2231
100 Horses and Mules Always on Hand!

Real estate and improvements to be sold at time of Auction, comprising lot 100x175 residence, barns and all improvements thereon.

T-P July 5, 8: States July 8, 1942.

E. Adema's Etta Dairy was up for auction on July 9, 1942. *TP.*

The nearby Pontchartrain Dairy was owned by the DeDebants and located at 1816 Live Oak near the boat launch. An October 26, 1943 *Times-Picayune* ad stated, "Mr. DeDebant is selling out on account of no help—100 cows, two bulls, five acres, new barn holds 116 cows, seven-room house, electricity, city water, all the pastures you want $7500.00." He did sell it in 1947. However, J.B. Dedebant operated it until about 1965.

MIGHTY GIANT (1968)

The Mighty Giant offered a "Big 3 Selection" of giant burgers, broiled ham sandwiches or hot roast beef sandwiches at 5036 West Esplanade at Transcontinental. There was a Kiddie Korner for the younger customers in this local franchise that never took off. It was incorporated by brothers Frank and William J. Gruber of the Meal-A-Minute family. Billy Gruber later had Liuzza's by the Track. The Mighty Giant location was later Music Box, then Short Stop Poboys. It was located in the Continental Shopping

Center owned by Senator William J. Gruber, who, in 1966, planned to have a Shainberg's and one of his Meal-A-Minit restaurants located there.

Airline Carpet Golf (1964)

In 1964, the short-lived Airline Carpet Golf course operated behind the Frostop—both owned by Ted Sternberg—at 4637 Airline. After little success, he offered the $10,000, ten-thousand-square-foot course to charity.

Putt-Putt on Causeway (1959–1965)

Miniature golf courses began sprouting up in the New Orleans area in the 1920s. In the 1940s and '50s, mini-golf tournaments were held at several locations. By 1957, Harry Batt added "Around the World in 18 Holes" to Pontchartrain Beach's attractions, but it wasn't until 1959, when Putt-Putt Golf opened at 2210, that Metairie had a course. It closed in 1965.

Kartway Go-Cart Tracks (1960s)

Metairie Kartway tracks could be found on Vets, David Drive and Causeway.

O'Shaugnessy's Recreation Parlor (1940–1965)

O'Shaugnessy's offered a mezzanine buffet, men's and women's showers and a complete Texaco service center. The second-floor billiard hall and wonderful neon sign depicting a bowler in action, perpetually scoring a strike, were added later.

Six partners were involved in this venture, including Arthur O'Shaughnessy, who was also vice president and general manager of Southport's Great Southern Box Company. The bowling business was so good that, within a year, twenty more lanes (equipped with modern "Tel-E-Score" and "Tele-Foul" equipment) were added in an extension to the rear

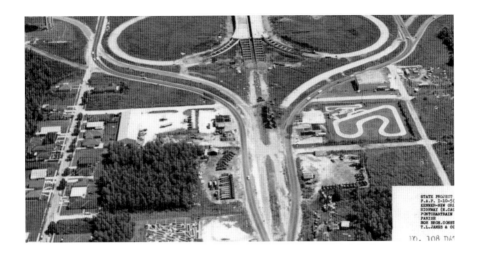

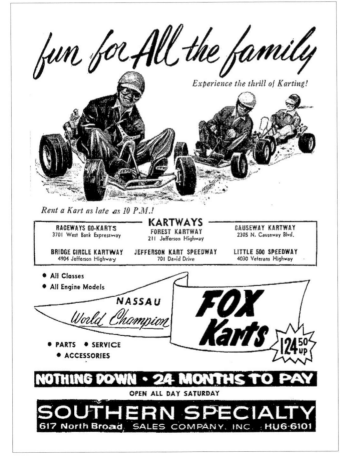

Above: The Causeway/I-10 loop under construction in 1964. The Putt-Putt course is left of the causeway near the bottom of this photo. Causeway Kartway is on the right, near the loop. *LDL.*

Left: A May 26, 1961 *Times-Picayune* ad for Kartway Go-Cart Tracks. *TP.*

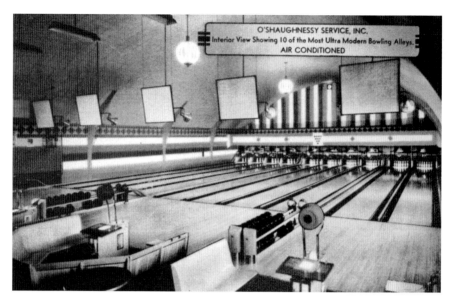

Undated postcard of O'Shaugnessy's Recreation Parlor. *AC.*

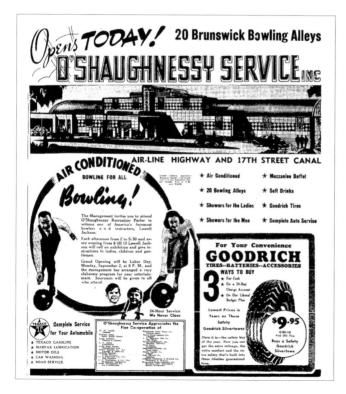

On Labor Day, September 2, 1940, the massive, air-conditioned, twenty-lane bowling parlor opened at 101 Airline at the New Orleans parish line. *TP.*

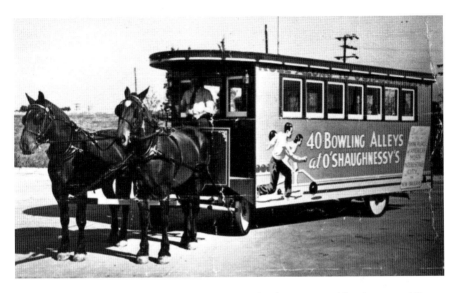

During World War II gas rationing, a horse-drawn shuttle transported bowlers to and from O'Shaugnessy's. *Maunsel White*.

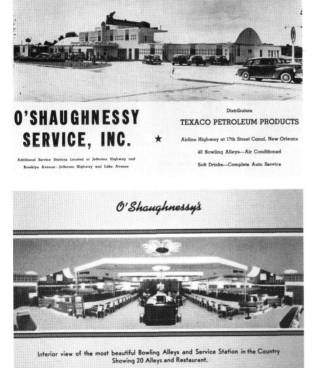

Left, top: A 1945 ad for O'Shaugnessy Service, Inc. O'Shaugnessy's empire included two other service stations, at Jefferson Highway at Brooklyn Avenue and Airline Highway at Williams Boulevard in Kenner. *TP*.

Left, bottom: Undated O'Shaugnessy's postcard boasts of "the most beautiful Bowling Alleys and Service Station in the Country." *AC*.

of the building. The owners optimistically predicted that there was room for fifteen more. This was one of the largest and finest bowling alleys in the country.

In 1942, as wartime gas rationing was in effect, O'Shaughnessy's hired out a horse-drawn wagon to carry patrons from the corner of Carrollton and Tulane Avenues to and from the business three times a day. Owners of the nearby Mid-City Lanes at that intersection were undoubtedly not amused.

In 1946, a full sporting goods center was added, complete with bowling, tennis, table tennis, badminton, archery, softball, baseball, golf and boxing equipment. At this time, the lanes were open twenty-four hours a day with the exception of Sundays, when closing time was midnight.

After twenty-five years in business, O'Shaughnessy's big recreation center was sold in 1965. It sat vacant for several years before a massive fire destroyed it all on July 19, 1968. Only the steel girders remained. Gone was the landmark at the parish line.

ARNOLD PALMER PUTTING COURSE (1965–1968)

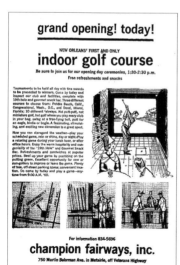

"Not putt-putt, not miniature golf, but golf where you play every club in your bag," noted this advertisement announcing the opening of Champion Fairways on February 11, 1966. *TP*.

This course opened at Lakeside Shopping Center in 1965. Palmer was there for a demonstration soon after the opening, as he was in town to play in the New Orleans Open. The course closed in 1968.

CHAMPION FAIRWAYS (1966–1967)

A seemingly spectacular indoor golf venue opened at 750 Martin Behrman Avenue near Vets in 1966. As the county's third indoor simulated golf course, Champion Fairways allowed golfers to fully swing any club into a screen on which the fairways were projected via 35-millimeter film. A computer calculated the ball speed, intensity, distance, degree of hook or slice

and yards remaining to the flag. The facility also included a nine-hole practice green and a "19th Hole Gourmet Snack Bar." This high-tech fantasy world was made possible by equipment manufactured by Product Investors Company. Similar "courses" had also opened in Japan, Paris, London, New York and Atlanta, but the folks in Metairie apparently were not impressed; by 1968, Maison Boeuf Steak House was located here. Future businesses at this site included Chateau Rib restaurant (1972), the Heritage banquet and bingo hall (1972), Dick Burke's Channel Club (1977), Rohm's Florist (1997) and, finally, Villere's Florist.

METAIRIE RIDGE SCHOOL/METAIRIE HIGH (1909–1968)

Alfred Bonnabel donated land for the second Metairie public school, Metairie Ridge School, which opened at what is now 1416 Metairie Road in 1909. Due to increased enrollment, in 1923, a large brick building was under construction, and the school was renamed Metairie High even though it included grades one through twelve. When East Jefferson High opened in 1955, the school was converted to Metairie Junior High under the leadership of Vernon C. Haynes. The lovely brick edifice, said to be in disrepair, was demolished in 1968, and the current structure fronting Metairie Road was built. Through the years, it has been named Metairie Middle School (1969),

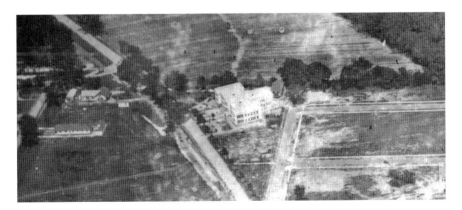

An early view of Metairie High, before homes and businesses surrounded it. *Maunsel White.*

Vernon C. Haynes Middle School (1974), Vernon C. and Gilda P. Haynes Middle School (1995), Middle School for Advanced Studies (2004) and Haynes Academy for Advanced Studies (2006).

I-10 CONSTRUCTION (1959–1960S)

The state highway department opened an office at 1708 Socrates in 1959 to handle acquisitions of the right-of-way for the Federal Interstate Highway (referred to then as IH for "Interstate Highway"). The office received appraisals, passed acts of sale, charged no closing costs and

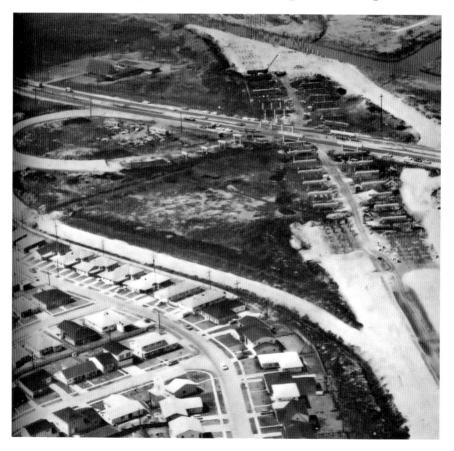

A 1965 view of Veterans Highway (running east to west near the top) as it intersects with the roadwork. *JPYR.*

then ordered that homeowners evacuate within thirty days. Work for the highway began between the parish line and Causeway during the summer of that year.

Socrates Street was ground zero. It no longer exists—the highway follows its old path through Old Metairie. All homes that intersected with it were either destroyed or have been moved. This continued through the heart of Metairie to the Kenner line. In 1959, as an example, the following homes were being sold to be moved: 1304 Socrates, 544 Melody, 527 Orion, 211 Holly Grove (near I-10/610 split), 559 Hesper, 331 East William David, 444 Brockenbraugh, 549 Papworth and 331 Sena. In 1960, houses for sale to be moved included 559 Phospher, 551 Orion, 2600–2700 Haring, 2712 Green Acres, 543 Phospher, 553 Homer and 329 West William David.

The construction of this section alone had taken two years. In 1963, the contract was inked for the construction of IH bridges, and the removal of homes began in Metairie. Trees and streets were eliminated in 1964. The following year, land was cleared and bridge building began at Oaklawn and Bonnabel. A homeowner on Beverly Gardens at the service road cut off a few feet of a home to spare it, but hundreds of homeowners lost their property. Metairie has yet to be the same.

AZALEA DAIRY (1940S–LATE 1960S)

Joseph A. Root & Sons operated out of 84 Metairie Court. An August 14, 1941 *Times-Picayune* article notes that this dairy was one of the first in the area providing fresh milk pasteurization, whereby the cows were milked in the morning, their milk was then pasteurized and delivered the next morning—twenty-four hours from cow to consumer. The cream on top remained liquefied because the milk was so fresh it had no time to coagulate.

After Joseph died in 1960, the dairy was operated by his sons. Joseph Jr. ("Buddy"), who had worked there, fought in World War II and then returned to the family business. He is remembered by many as the driver (after the dairy closed) of Jefferson Parish Schools bus no. 308. He passed away on May 25, 2011, at the age of eighty-three. Floyd Alfred "Al" Root Sr., also a war veteran, died on December 11, 2003, at the age of eighty.

GROUND FIRES (1940S–LATE 1960S)

Swamp prairie fires are products of nature, ignited by lightning in drought conditions. Rain would then replenish the marshes, and the growth of prairie grass would begin anew. But after Metairie's swamps and marshes were drained by pumps, the marsh grasses died; what remained was highly volatile vegetable matter buried under new scrappy growth. As much as three feet of humus comprised the topsoil and it, too, burned hot and easily, especially below the surface.

Beginning in the late 1940s and continuing into the late 1960s, man-made ground fires plagued the area. Developers chopped down the ancient cypress and other trees. The felled trees and/or their stumps would be burned or dynamited to clear the land for building. In areas now occupied by subdivisions, hunters set fires to force their prey from cover.

When fog rolled off the river or lake, it combined with smoke from the fires to create dense smog. Although much of Metairie was as yet vacant of housing, those who lived there or traversed through it were highly affected. In November 1949, parts of Metairie were engulfed in a miasma for almost two weeks. Visibility was reduced to a few feet, and driving conditions were hazardous. Traffic on Airline Highway was often at a standstill, and twenty cars were involved in accidents, one resulting in a fatality. Flights were delayed at Moisant (now Louis Armstrong International Airport) due to passengers' inability to reach the airport. A total of one hundred inbound fliers spent the night at the airport because they couldn't venture out. One fire was near the East End School in Bucktown. Another was near Clearview Parkway between West Metairie and West Napoleon. Others were along the lakeshore. Clearview/Bridgedale residents dug trenches around their homes and flooded them in hopes of breaking the fire. When flare-ups occurred, they extinguished them with buckets of water. Sheriff Frank Clancy ordered that pumps be placed in nearby canals to flood the deep ground fires.

The fires became more problematic and more widespread in the 1950s. In 1950, a fire along four blocks between Focis and Rosa left visibility on Airline Highway obscured for a full mile, resulting in several auto accidents and a business on the highway in flames. In 1952, fires near the lakeshore as well as near Brockenbrough Court between Metairie Road and the lake resulted in massive smog, minimum visibility, traffic jams and more auto accidents, including another fatality. Sheriff Clancy called for bulldozers to uproot smoldering cypress stumps and the digging of fire breaks.

In 1953, while Veterans Highway was being planned, designers warned that 300,000 truckloads of combustible soil and stumps had to be removed and replaced with fill before laying the roadbed. As much as 37 percent of the reclaimed swampland was composed of combustible soil. In 1954, smog caused parts of Airline Highway to be closed to traffic, planes at Moisant were grounded and public transportation in Metairie, West End and Jefferson were affected. Bronchial problems were on the rise, and traffic accidents continued to occur. Local meteorologists began including smog predictions in their forecasts. The problem was becoming so onerous that five parishes joined in an effort to reduce smog by eliminating all unnecessary smoke. Nash Roberts headed a fact-finding committee to study the problem, which was thought to be exacerbated by the burning of trash at the parish incinerator at David Drive and Airline as well as industrial burnoff along the river.

By 1956, uncontrolled fires started by contractors burning brush and building waste were so widespread that Sheriff William Coci and the police jury issued orders that permits be required for burning—and only then under the supervision of parish authorities. This led to an abatement of major fires until 1963, when a fire burned between West Napoleon, West Metaire, Woodlawn and Houma Boulevard. In 1968, perhaps the worst of them all burned along Clearview Parkway between West Metairie and West Napoleon. Smoke filled the area between Airline and the Vet. Homes were threatened, and a state of emergency was declared by the parish president. The fire burned for more than twenty-four hours until finally extinguished by fire trucks and bulldozers—a hazardous task, as this underground fire left a thin crust of dried soil on top of an unseen vacant chasm of still-burning vegetation. While this was a major event, firefighters expressed a casual attitude. Small fires of this type had become commonplace, and if no lives or homes were threatened, the firefighters would routinely work days, leave the fires burning through the night and then return to the fire the following day. After Metairie was fully developed, these fires became a thing of the past.

5

BONNABEL PROPERTY
(1836–1968)

French-born Jules "Henri" Alexandre Bonnabel, who made his home in New Orleans, was a chemist, drug wholesaler, retailer and manufacturer of bisulfate of lime used in brewing and purification of sugarcane juice. On September 28, 1836, he purchased from Hypolite de Courval a half interest in twelve arpents (approximately 2,300 feet) along Metairie Road/Bayou stretching from the river to the lake. As a condition of the transaction, a portion of the tract, 240 feet wide and 1,100 feet long, was reserved for a proposed railroad (probably the "Bath Railroad," whose car house was built near the lake).

BATH LOT HUMBUG.—A gentleman has informed us, that several of the purchasers of lots in the new town of Bath, recently *went down* there on an exploring expedition. On arriving at the Lake, they procured a boat, lead-lines, and other materials for sounding, but were generally unsuccessful in their search. One poor fellow, however, was fortunate enough to find his purchase, although it was located in *fifty fathom water!*—When will the rage for speculation cease?

Since writing the above, we have read in yesterday's Courier, an excellent and a humerous article, withal, giving an account of a Frenchman, who was lately taken in somewhat in the same manner of our Bath lots purchasers. It is copied from the New York Mirror, and we shall try and make room for it in a day or two.

Through the years, the Bonnabel family bought and sold much property, but their "Town of Bath" was a washout, as is attested in this satirical article from the *Picayune* published on February 4, 1837. *TP.*

The proposed Bath Railroad would run through the proposed town of Bath along Bath Avenue, now Bonnabel Boulevard, which runs along the ancient (but seldom known) Bonnabel Ridge. *1867 Gardners City Directory.*

Bonnabel and de Courval collaborated in laying out the "town" (which was only imagined on paper), assigning the numbered street names we still use today, with the first street starting at the lake and counting up to Forty-Fourth Street at Metairie Road. Bonnabel and de Courval sold many lots and squares to other parties, but by about 1837, de Courval had sold the remainder of his landholdings to Bonnabel.

New Orleans and Nashville Railroad (1838–1842)

Built in the 1830s, this railroad's tracks headed straight out from New Orleans's Canal Street and along what would become Metairie's Canal Street to the lakeshore between Bayou Labarre and Bayou Laurier and through the "town" of Bath. On the lake was a ferry dock for transport to the north shore. Bridges were built across Indian Bayou and Bayous Tchoupitoulas and Labarre. By 1835, six miles of rails had been completed and the road was graded to Bayou Labranche. In 1842, the enterprise fell into insolvency.

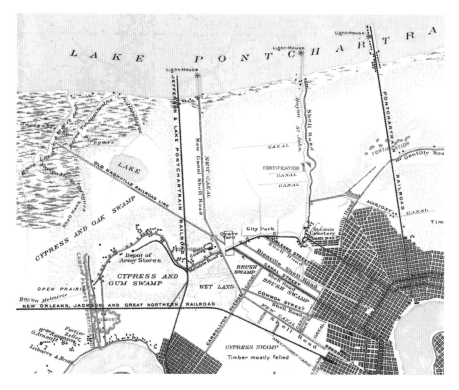

This 1863 map shows the path of the "Old Nashville Railroad," as well as Bayous Tchoupitoulas and Labarre and Indian Bayou. *AC.*

Prairie Cottage (1838–1842)

At the lakeshore was the Prairie Cottage, a first-class resort on high ground with a beach. Built in the late 1830s, this endeavor proved very successful with its good restaurant, bar, family-friendly rooms, billiards rooms, pistol and rifle range and quoit-pitching (akin to horseshoes) courts. Named for its expansive view of the swamp prairie that was spread back from Metairie's lakeshore, it hosted popular regattas and pistol matches and provided sailboats, seine fishing and bathhouses. In March 1842, the main building burned to the ground. The proprietors promised to rebuild, but with the failure of the railroad that brought city folk here, the resort was doomed in this pre-automobile age.

Nearby, Henri Bonnabel built a large summer home, oversaw the raising of tobacco and then cotton by slaves and leased portions of his land for timbering and other interests.

Camp Parapet's Cavalier, Fort Star and Embankment (1861–1953)

During the War Between the States, Henri's son, Alfred, enlisted with the Confederacy and used the land to actively aid the cause. Union troops looted and destroyed the family mansion and farmlands and encamped on the property's ancient Native American mounds and middens near the Bayou Tchoupitoulas.

Fort Morgan, named for Confederate general John Hunt Morgan, was established in 1861 near the foot of Harlem Avenue (now Causeway) at the river in the "Town of Harlem" (which existed as early as 1844) to protect New Orleans from invasion by Federal troops. It was renamed Camp Parapet after its capture by the Union in 1862, when Federal troops extended its jagged earthen protection embankment (the parapet) to about what is now Forty-Second Street. The structure measured nine feet high, twenty-seven feet wide with an eight-foot-wide ridge fronted with a forty- to ninety-foot-wide, seven- to nine-foot-deep moat. At that end, Fort Star, which included a powder magazine, was built to defend against an attack from the lake. Between the two forts, near Metairie Road, was the Cavalier (a higher fort within the complex). In the early 1900s, some of the structures and lines of entrenchments still remained, but all that is left now is the main powder magazine near the river, restored in 1981 after declaration as a National Historic Place in 1977.

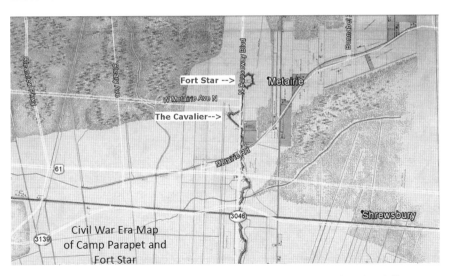

This illustration by David Lynch compares the past to the present. *St. Catherine of Sienna Knights of Columbus Council 12686 (www.council12686.org).*

In 2016, in one of Bruce Boudreaux's wonderful interviews with Metairie residents recalling their pasts, he shared transcripts from a recording made by James Gennaro of his father, Emile, who was born in 1917. Emile said, "At the corner of Causeway and Cypress, where I live, was known in those days as *The Fort*. It was an area from Causeway to Athania and West Metairie to the streetcar line [Cypress Street]. There used to be a *big hill* there. Gypsies camped in this area during the wintertime."[5] "The Fort" might have been the remains of Camp Parapet's Cavalier, and the "big hill" could have been the powder magazine within the fort.

Emile Gennaro also remembered, "The National Guard had a *rifle range* fronting the street car line near Athania Parkway. The rifles were fired from 100 to 500 yards to the targets. A *mud levee* was built to protect the boys operating the targets. Myself and many of the young men and boys operated the targets at that time."[6] The "mud levee" was likely Camp Parapet's embankment (after the war, it was considered for use as a flood protection levee), which once had cannons atop it. And the "rifle range" itself remained for many years after.

A BEAR IN OLD METAIRIE (1872)

The *New Orleans Republican* newspaper noted on June 30, 1872, "A report has reached Mr. Charleville's gun store, No. 55 St. Charles street, that a large bear was recently seen on Mr. H. Bonnabel's place, on Metairie Ridge. A number of hunters will go for him."

BONNABEL BEACH

Upon Henri Bonnabel's death, his property came into the possession of his widow, Julia McCarthy, until she passed away on May 8, 1875, and the land was passed down to their seven children, six of whom sold their interests to their sibling Alfred that same year. Alfred Bonnabel lived on the family land, overseeing the raising of cattle, dairy cows, rice and vegetables while leasing sections of the property to businesses and tenant farmers (the foundations of their homes were still visible one hundred years later).

He built a summer home on Bayou Tchoupitoulas, improved the lakeshore beach and made a lively spot for picnickers and bathers near the ancient

remains of Native Americans. Alfred named the area "Lake City," hoping that residences would also be constructed there.

Around the turn of the century, he drilled a nine-hundred-foot artesian well that terminated with a two-and-three-fourths-inch pipe rising eight feet above high tide. It produced twelve gallons per minute at a temperature of seventy-nine degrees. Geologists believed that it shared the same stratum as the Abita Springs, but it produced barely potable water. The beach resort was popular for a time, but this second attempt to build a business and community along the lake failed, due possibly in part to the lack of fresh drinking water.

Lillian Shultz Razza recalled this place from her childhood in Bucktown when it was a fishing village, as reported by Frank Schneider in his Second Cup column in a piece titled "The Perfect Place to Live Their Lives" in the *Times-Picayune*. She remembered a canal that later became Hammond Highway and the constantly flowing water well terminating with a rusty pipe along the lake shoreline near the "Indian Mound" where children found arrowheads and pottery shards.[7]

STATE RIFLE RANGE/CAMP GARDINER (1907–1953)

In 1907, a ten-year lease for the National Guard rifle range in the Bonnabel pastures was signed. The range was in the newly opened Camp Gardiner. It is possible that Camp Gardiner was located at the old Fort Star. It opened in 1908, about a mile up from Metairie Road near Shrewsbury/Severn. On Sunday, November 28, 1909, it was officially named Beauregard Rifle Range during a celebration which included a band and dancing.

A 1920 description of the entire one-hundred-acre property tells us that it was 300 feet wide "behind Athania Place" by two and a half miles to the lake (where it occupied a 298-foot-wide area along Hammond Highway). In the 1920s and '30s, it was often referred to as "Shrewsbury Range" and was the site of football games and public shooting matches. The range also included a powder magazine, possibly remnants of the Civil War.

In 1926, the government swapped the Metairie land for private property near Alexandria for what would be an improved Camp Beauregard there. The Metairie land changed hands several times but remained undeveloped, while the portion from Cypress to Forty-Second Street was divided from the original property. In 1953, Paul Brignac sold Jules J. Viosca the land

The rifle range location (*left of center*) is shown in this undated map. *AC.*

north of Forty-Second Street to the lake for $100,000. Viosca named it Athania Parkway and divided it into 50-by-119-foot lots. The plan for his street to cross Veterans Highway was undone when Lakeside Shopping Center was built.

AETNA POWDER MAGAZINE (C.1905–1940S)

The Aetna Powder Magazine was in such dangerously close proximity to the State Rifle Range that, in 1908, the parish required its removal from the Bonnabel property. That did not happen. It was described in 1910 as being one-half-mile wide with concrete walls lined with sheet iron surrounded by a ditch serving as a firebreak. It was still there in the 1940s.

DUPONT POWDER MAGAZINE (1911–1930S)

In 1910, the police jury set aside swampland between Metairie Road and the lake for the E.J. Dupont Powder Company magazine. It was constructed

in 1911, two miles from the Aetna magazine. In 1912, under the Sherman Anti-Trust Act, the DuPont facility became the Atlas Powder Magazine. The following year, under a five-year lease (with one year remaining), property owners petitioned to declare it a public nuisance, but it remained until at least 1933, when a stump and grass fire threatened to ignite a dynamite shed in the vicinity of the pumping station at the Bonnabel Canal.

CARROLL TRACT (1910–1925)

These 250 acres (almost one mile along the shoreline) were sold to the Lake Front Development Company in 1925 for $250,000. The company, organized and represented by developer James F. Turnbull, included high-roller investors Meyer Eiseman, Eldon S. Lazarus, Lyle A. Aschaffenberg and Leon C. Simon. They had plans for a levee and highway along the shore and high-terraced grounds for homes at what would now be bounded roughly by Bonnabel Boulevard, Claudius and Carrollton in what we now call Bucktown.

After sitting idle for years (but with the well still flowing), the would-be Lake City resort area was purchased in 1910 by attorney Charles Carroll for $180,000. This is a detail from a 1924 map. *AC.*

BONNABEL PLACE SUBDIVISION (1914)

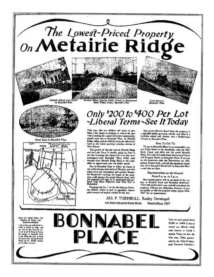

This June 26, 1927 advertisement shows the Metairie Ridge public school as well as the new St. Catherine Church and school when Metairie was incorporated as a town. *TP.*

Alfred Bonnabel converted Bath into the Bonnabel Place Subdivision in 1914. It was a success, as were the other subdivisions that were sprouting up along Metairie Road at that time (Crestmont, Metairie Nursery, Metairie Ridge and Metairie Heights, to name a few), because the streetcar and automobiles made them accessible. Alfred's wife, Luella, named the streets after mythological, historical and literary figures.

Alfred Bonnabel, now known as the "Father of Education" in Jefferson Parish, died on April 30, 1921, at age eighty-three. He had been the director of schools and served on the school board from 1872 to 1918. Having spent the majority of his life devoted to community service, Alfred Bonnabel was also a longtime member of the police jury.

OLD HOMESTEAD SUBDIVISION (1922)

After his father's death, Alfred E. took the reigns and further divided the family homestead due east of Bonnabel Place into 350 lots at 50 by 120 feet and 60 by 150 feet. Homestead Avenue is the location of the Bonnabel home. Brockenbraugh Court honors Alfred's wife, Laura Brockenbraugh Rappelye.

NEW ORLEANS–HAMMOND HIGHWAY (1920s–1940s)

An ambitious plan to continue New Orleans's proposed Lakeshore Drive through Metairie to Pass Manchac and up to Hammond began in 1916 with a bill introduced by George Abry of Orleans and Jesse Remick of St.

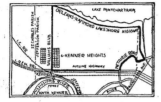

FORMAL OPENING

of

New Orleans-Hammond Lakeshore
and
Williams Boulevard Highways
Today, Sunday, May 17

The Mayor and Town Council of Kenner have pleasure in inviting you to be present at the formal opening of the New Orleans-Hammond Lakeshore and Williams Boulevard Highways, on Sunday, May 17, 1936. Joining in this celebration are the following organizations: The Jefferson Parish Police Jury, the New Orleans Chamber of Commerce Good Roads Bureau, the New Orleans Real Estate Board and the New Orleans Property Owners' Association.

It is proposed to hold a motorcade, traveling over the route as shown by the heavy lines on the above plan, and to hold a public meeting on the lakefront at the junction of the Lakeshore Highway and Williams Boulevard at 3 o'clock p. m., those joining the motorcade are requested to meet at 2:30 p. m. at the junction of Metairie Ridge, Shrewsbury Road and Airline Highway.

If the road is dry we have permission to ride over the Airline Highway to Kenner, failing which the route will be over the Jefferson Highway to Kenner.

This drive of 25 miles including the 10 miles along the lakeshore will be a boon to thousands who have long waited for this improvement, while many thousands of acres of vacant land embraced in this area will be more accessible and more desirable for homesites and small farms.

Very truly yours,
V. D. GEROLAMO,
Mayor of Kenner.

The Kenner School Band will render the music for the occasion.

This Announcement Sponsored by

M. M. Jones, Inc.
828 Union St.
Asset Realization Co.,
Inc.
1409 Whitney Bldg.
Town of Kenner, La.

Alfred E. Bonnabel
205 Homestead Ave., Metairie
J. W. Sheldon
208 Vincent Bldg.
Codifer & Bonnabel, Inc.
312 Balter Bldg.

Above: The deteriorated condition of Hammond Highway is seen here in 1949. *JPYR.*

Left: Note that Alfred E. Bonnabel is a sponsor of this announcement of the formal opening of the New Orleans–Hammond Highway. *TP.*

Charles before the statehouse. In the 1920s, a levee was built six feet above Gulf of Mexico high-tide level, topped by a road. The drainage district of 1922 included Orleans, Jefferson and St. Charles Parishes, which completed the levee. The state highway commission, builder of the gravel-and-shell road, defaulted on the plan before it was completed. However, the formal opening of the ten-mile stretch between the city and Williams Boulevard was celebrated on May 17, 1936.

Lack of maintenance accounted for road and levee sinkage and erosion. The unnamed hurricane of September 19, 1947, further damaged the structures, which then sat low enough to allow high-level lake water onto the land while also being high enough to retain storm-driven water on the land side.

As new subdivisions were being developed, the need for flood protection became more important; almost half of East Jefferson Parish (thirteen thousand acres) lies below sea level. By 1949, another ambitious plan was floated: a seawall to be created by dredging lake sand 2,200 feet offshore and depositing it between two retaining walls 10 feet above sea level (as is the New Orleans seawall). And like the city's lakeshore, a road would be built on

the land side. This plan never came to pass, and all that remains of the New Orleans–Hammond Highway is the section between West End Boulevard and the five-block stretch into Bucktown, terminating at Chickasaw Avenue.

Drainage

On Friday, January 21, 1927, Jefferson Parish Pumping Station No. 1 went online, via the recently completed Bonnabel Canal (construction began on it in 1922). It drained the area between Metairie Road, the Seventeenth Street Canal, the Orleans Parish line and Lake Pontchartrain—a total of sixteen hundred acres. It was the first of four pumps along Metairie's lakeshore that would dry the swamps and contribute to the draining of ancient bayous.

The four stations would empty the entire Jefferson Parish east bank, a total of thirty thousand acres, at a rate of one million gallons per minute. They were/are at the mouths of the following canals: the Duncan Canal along the St. Charles/Kenner Parish border (at Alligator Bayou); the Elmwood Canal between Clearview and Power Boulevard near the mouth of Double Bayou; the Suburban Canal, which parallels Houma Boulevard from West Metairie to the lake and contributed to the draining of Bayou Laurier; and the Bonnabel Canal (draining Indian Bayou, Bayou Tchoupitoulas and Bayou Labarre). In the 1930s, the mouths of Bayous Laurier and Tchoupitoulas were dug into canals one hundred feet wide and eight feet deep.

Circles indicate pumping station locations. *St. Catherine of Sienna Knights of Columbus Council 12686 (www.council12686.org).*

Back to the Beach

The first link of the New Orleans–Hammond Highway made the lake end of the property accessible; Bonnabel Beach experienced a new era of popularity. In 1932, Alfred E. was making plans for a wide street to connect it to Metairie Road. The image labeled "1" in the 1932 newspaper article shown on page 77 captures an 1897 view of Bonnabel Beach's pavilion. Image 2 is a 1932 view, and image 3 shows a barely discernible Alfred E.

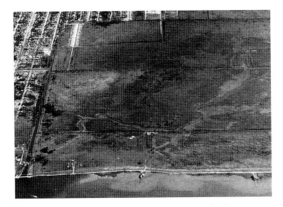

Left: This 1952 view shows the bayous, mounds and middens (adjacent to the canal), with civilization encroaching. *Charlie Everhardt via Maunsel White.*

Below: Current map of the same location. *Google Maps.*

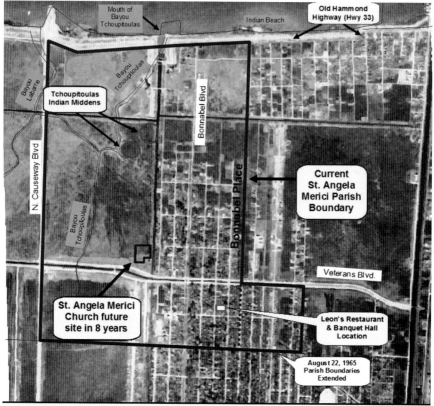

1956 Aerial Photo (northeast Metairie)
(Aerial photo courtesy of the Jefferson Parish Yearly Review) (geo-referencing & annotation by Eric Broadbridge)

A 1956 view of the Tchoupitoulas Indian Middens. *St. Angela Merici Parish website (http:// stangela.homestead.com/ParishHistory.html)*.

Bonnabel pointing to the "Indian Mounds," which were at this time covered with grass, brush and oak trees. The sand and shell beach was accessible by car on the new highway; the *Picayune* reported that on weekends as many as one hundred cars might be parked along what old maps labeled "Indian Beach." The mounds were a short walk from the beach or could be reached by boat on the Bonnabel Canal. They were bounded roughly by what is now West Esplanade to Twenty-Second Street and from Clifford Drive to the Bonnabel Canal.

Native Americans created the beach with discarded clamshells. They also transported clams from the lake along the bayous to where they were eaten and discarded, creating three distinct middens at their common ground near

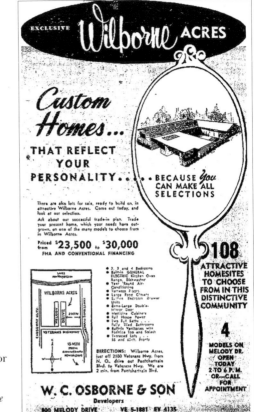

Right: A June 9, 1957 advertisement for Wilborne Acres subdivision. *TP.*

Below: An April 7, 1932 *Times-Picayune* article. *TP.*

present-day Nero Street at Metairie Court. They used these as high ground during times of high water. They also buried their dead here.

Margie Vicknair-Pray related the memories of her cousins and brother, Clifford "Kip" Vicknair, from the 1950s:

> *There were Indian mounds all over the area. One huge one was right about where Clifford Drive comes into West Esplanade. There were skulls and pottery and arrow heads to be found there. There was also a point, now covered by the big levee and bike-path fill, that we called Indian Point. It jutted out into the lake a few blocks east of Bonnabel and was a treasure trove of arrow heads and pottery pieces.*

The mounds had been studied as far back as 1935, when an archaeological dig was conducted by LSU. A 1959 dig revealed a human femur and tooth, gar scales and pottery shards in the middens, which were thought to have been constructed during the Tchefuncte period as early as 400 BC. Archaeologists concluded that, before their degradation, the largest midden, home of the chief and other leaders, was fifteen feet high. The other two were roughly three hundred feet away, housing more dwellings. All were fortified with a six-foot-high ridge. Legend has it that,

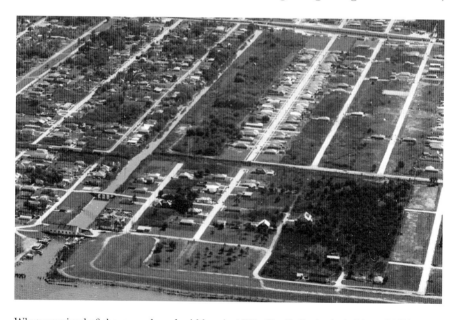

What remained of the mounds and middens in 1961. *Charlie Everhardt via Maunsel White.*

after a horrific storm, the Tcoupitoulas paddled to Bayou Metairie, made their way to the Mississippi River, crossed over, continued on to Bayou Lafourche and settled with the Houma tribe, while others crossed the lake to what is now Mandeville and joined the Biloxi tribe.

In 1957, W.C. Osborne & Son built the first model home in its Wilborne Acres development at 800 Melody Drive. In the same year, it extended Beverly Garden Drive through undeveloped land just north of Veterans. The company had plans for a 108-site, thirty-five-acre subdivision.

As the subdivision progressed, by 1959, the area around the Indian Mounds had been reduced to a few oaks, a small mound and a hill of shells pushed by bulldozers. A paved street replaced the old dirt path to the mounds. Melody Drive had been paved almost to the ancient site, with new homes adjacent to it.

William Osborne Jr. became president of the company after his father's death in 1964 at the age of seventy-two. In 1968, William opened the last section of the Melody Drive–Beverly Garden development—twenty-four homesites in the 1200 block of Beverly Garden. Bayou Tchoupitoulas had been completely filled, and the Indian Mounds were history. Of course, the Osbornes were not the only developers to encroach and destroy the remains of an ancient civilization and the bayous they traveled upon in Metairie. The Osbornes were simply the last.

Third-generation Bonnabel landowner Alfred E. Bonnabel died in 1951. He was a founder of the Metairie Ridge Volunteer Fire Company and a longtime parish surveyor. His wife, Luella Van Vrancken, was the first school principal of the Metairie Ridge School as well as of Metairie High School.

6

FAT CITY

"Fat City" in Metairie someday might be as established as is Lakeview or Bucktown. Business men in the area bounded by West Esplanade to Veterans Highway and from the Causeway to Division Street, organized Monday night as the Fat City Business Association.[8]
—*Howard Jacobs,* Times-Picayune, *February 22, 1973*

Fat City merits its own chapter. At its peak, it was a city within the "city" of Metairie. And although it still physically exists, it passed its prime years ago, ceasing to exist as it once did. Its name was coined in 1973, when local developers laid out a plan to convert a parcel of land into an entertainment and apartment complex district. Local lore traces its name to an eight- by ten-foot yellow stand at Severn and Seventeenth Street owned and operated by teenage brothers David and Denis DeVun, who named it "Fat City Snowballs." Others have said its name was partially derived from *Fat City*, the 1969 novel by Leonard Gardner that was later made into a movie.

The news brief quoted at the outset of this chapter was followed up on March 1 with an article titled "Fat City to Be East Jeff's Vieux Carre–Type Area." Writer Emile Lafourcade Jr. noted that the 104-block "Fat City" area already contained many of the parish's businesses and held the largest concentration of apartment complexes. "In an effort to bring the area a life style and business viability similar of that of the Vieux Carre, the Fat City Bushiness Association (FCBA) was formed." The forty Jefferson Parish

A 1974 photo of Fat City Snowballs. *Ralph Uribe.*

businessmen (note that there is no reference to businesswomen) included David L. Levy, president; Roy Anselmo, vice president; Chris Wiltz McElroy, secretary; Joe Riccobono, treasurer; and Murray Solow, publicity chairman. Solow expressed the need to make Fat City an official parish community whose goal was to "create an environment for cosmopolitan living" that "is easily identified by the outsider, just as most people who have ever seen the Vieux Carre or Atlanta's Underground can identify these areas when they see them in pictures."[9]

However, local resident Bill Theodore took exception to the name, writing a letter to the editor of the *Times-Picayune*: "To name a growing section of Jefferson Parish 'Fat City' after the name of a snowball stand is the height of fatheadedness. The name is ridiculous and ugly."[10]

Some of the lofty visions of the businessmen never came to pass, but some of the men made a mint in the forty-square-block area that has yet to fade from the memories of those who partied there. It all started with apartments—many apartments in a concentrated area rented by young people, many of them unmarried. In 1962, Studio Arms V (which became

Norwood in 1967) opened at 3500 Division Street (advertised as being located "at Veterans" but actually a block off the highway; nothing else lay between the apartments and the highway back then). Accommodations Inc. (an apartment finder) also operated here in 1964—boy, did it do a good job. Various smaller apartment houses sprang up in the area, but in 1964, the massive Butterfly Terrace at 2925 Edenborn at Vets opened, as did the large and luxurious Villa D'Orleans (no children, no pets), smack in the middle of what would become Fat City at 3030 Edenborn. In 1970, the Golden Key townhouses opened at 4051 Division. On the lake side of Drago's Lakeside Seafood restaurant, the Yorkshire townhouse development opened in 1971 at 3320 North Arnoult (prohibiting children and pets). The Pierre Marquis townhouses (3700 Division, lake side of the Norgate) and the adults-only El Matador (3512 North Arnoult) opened in 1972.

Soon after the apartments came the bars, which the young apartment dwellers (and suburbanites) frequented. The first of these were the Back Door near the Norgate, Act IV (later the Ski Lodge at 3224 Edenborn) near the Villa D'Orleans, Que Pasa (3201 Edenborn) and Roy Anselmo's Don Quixote's (3515 Eighteenth Street).

By 1973, there was Fat City Seafood, Golden Coin, Inn of the Rice Bowl, Wine-N-Lounge, the Place Across the Street, the Quarter Note, Roy Anselmo's Sancho Panza, Red Hot Lounge, Irish Mist (with go-go girls), Court Jester and Ship's Wheel. And there was the Red Caboose (a restaurant built inside an actual railroad car), Glen's Restaurant (3213 Arnoult Road, formerly Guzzo's), Little Joe's Italian restaurant, Breaux Mart, a Time-Saver, Pearl's Place and Europa Health Spa. The Lakeside Plaza Shopping Center opened at Severn and Seventeenth Street.

In 1974, Mike Zuppardo owned the Severn Plaza shopping center, Renata's Cucina Italian and the Spanish Galleon across the street from his Crystal Palace at 3608 Eighteenth Street. And then there was P.O.E.T.S., the Showboat Lounge, the Huki Lau, Rizzo's Pizza, Chateau Drugs and the relocation of Morning Call coffee from the French Quarter. There was the first Krewe of Argus parade, led by Emperor George Ackel, as well as the first Krewe of Jefferson and Elks of Jefferson parades and the "Fat City on Fat Tuesday" Mardi Gras costume contest.

Founding business association president David L. Levy predicted in 1974 that "by the end of the year we won't have any more land in Fat City."[11] Developer Joseph Canizaro noted that Fat City's fast-growing development was "a healthy kind of competition," but he presciently warned that if local authorities allow "a bad element to come in then they are entitled to

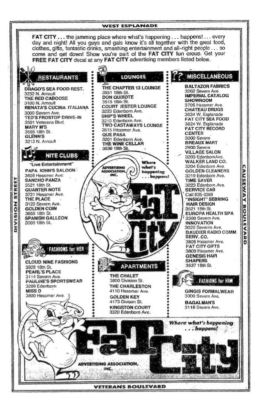

Right: An undated Fat City advertisement. *AC.*

Below: Pat Prince was crowned the first Miss Fat City in 1973. Here, contestants vie for the crown at the Jefferson Orleans at 2500 Edenborn Avenue in July 1975. *Robert Steiner, TP.*

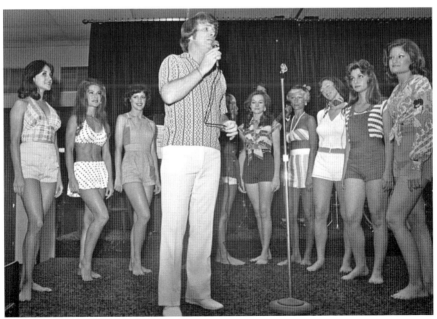

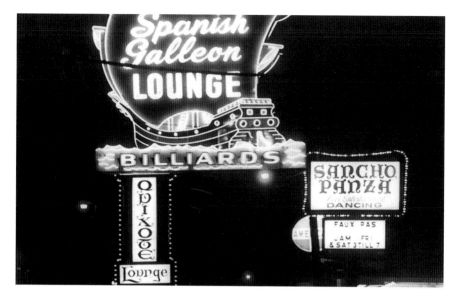

The bright lights on Eighteenth Street at Fat City Avenue between Severn and North Arnoult. *Staff photo, TP.*

what they get."[12] In the meantime, entrepreneurs in what we now call Old Metaire named a three-block strip along Metairie Road between Beverly Garden Drive and Bonnabel Boulevard "Skinny City," offering "skinny prices and fat values." The group formed the Skinny City Businessman's Association, which met at Pat Gillen's Bar. Businesswoman Tracey Bordes, coiner of the term "Skinny City," had no intention of competing with Fat City regarding nightlife "But we have an area with very little crime that offers the shopper everything." In September 1974, at Pat Gillen's, 380 voters from the Skinny City district elected "official" representatives: Louis Blanchard, mayor; Warren Mathews, sheriff; Hank Barrios, tax collector; Harry Luke, honorary judge; Mrs. Brefz Rim, entertainment chairman; and "Friar" Hermann Philippi, vicar.

In February 1975, echoing Joe Canizaro's concerns a year earlier, Jefferson Parish president Thomas F. Donelon called for stringent regulations in Fat City (there were fifty drinking establishments in one nine-block area alone), without which Fat City would become a land of "dilapidated lounges and bars." Donelon also noted that "Some of the owners have their hearts set on open gambling in Jefferson Parish" and that "if proper care is not taken, we will soon have a low-grade entertainment area in Fat City, accommodating all of the elements which are undesirable for the proper development of the

parish." Regarding Fat City businesses' economic value, he said, "Any credit for a financial contribution given that area is ridiculous. When the financial welfare of Jefferson Parish must rely on revenues from such areas as Fat City, then shame on us."[13] In that year, the Conquistador, Klassy Kat (with exotic dancers) and Club Follies (with dancing girls) opened. Candidates running for the first election for mayor of Fat City were "Sonny" Finney, "Sweet William" Grieshaber, "Joe" Musmeci and "Manny" Soto. And in New Orleans East, a group of investors envisioned "Slim City," hoping to bring Fat City–like ambiance to Lake Forest Boulevard.

The Fat City Business Association had spent its initial years touting the area as an entertainment district, but by January 1976, the group was "tired of the image of being a haven of fast pickup bars for swinging singles," as stated by its vice president for promotion, Vicki Karno. The demographics of Fat City were changing from underage and twenty-something patrons to folks between thirty-five and forty. Shopping at the retail outlets was on the rise, which contributed to more daytime dining. And the Playboy Club opened in the Crystal Palace location.

Although the name "Fat City" had been in common use, it wasn't until June 1976 that the parish council officially recognized the title as a place name. New openings included Melvin Facheaux's Dillinger's Night Club at 3612 Hessmer, offering "Live Floor Shows—11 P.M. and 1 A.M." and a gangster museum. Alicia's Palace, Fletcher's Nightery, Vincenzo's Restaurant, Oysters Eleven, the upscale Bobby McGee's super club (later named Mollie Maguire's) with Al Beletto entertaining, Joe and Josie Riccobono's Peppermill restaurant and C.J. Marcello's Fratelli's Deli were all there in 1976, the year Young's Chinese Restaurant and Lounge moved to Fat City from the lakeshore.

But all was not well. In January 1976, the Godfather Nightclub suffered extensive damage, including the destruction of its interior. This was the second fire here in several months. In July, Fletcher's Nightery on North Arnoult in Piccadilly Square burned for a total loss—the fourth fire in three months in a two-block area of North Arnoult, including damages to the Red Caboose, the Godfather and Glenn's. In August, Rizzo's Restaurant (behind Morning Call) was gutted, for a total of six major fires in three months.

In 1977, the business association erected a glowing 35-foot sign reading "FAT CITY" on the 150-foot tower of Lloyd Baudier's radio communications business at 3805 Hessmer Avenue (corner of Eighteenth Street). On a clear night, folks in St. Charles Parish and New Orleans East could see it. It was the tallest structure on Jefferson's east bank. A dedication ceremony was held

Above: In 1979, the 16,200-square-foot Front Page lounge was for sale. *TP.*

Left: "Fat City" in neon towers above Hessmer Avenue. *TP.*

for its lighting on the night that Eighteenth Street's name was changed to "Fat City Avenue" (the parish council had earlier approved the name change and erected new street signs).

Fat's City's glitter would soon fade; as it did, fires again lit the night sky. In January 1977, the Huki Lau suffered two blazes in a thirty-minute period, resulting in structural and interior damage. In September 1978, the Wine Cellar was gutted; all contents were destroyed, leaving it with heavy structural damage. In 1979, Warehouse West went ablaze on New Year's Eve.

Bridget O'Brian's front-page *Times-Picayune* article "Fat City Business Owners Admit Bad Planning Catching Up" on November 28, 1982, outlined its demise and history up to that time. Jefferson Parish did not enact zoning ordinances until 1958 and thereafter approved all applications. In the early 1960s, what would become Fat City had only four paved streets surrounded by mostly vacant land. In 1966, the Jefferson Parish Council adapted a policy whereby all existing businesses could remain in place but future development north of Seventeenth Street would be multifamily housing, with the southern portion of Fat City dedicated to commercial use. In the late 1960s, a single developer subdivided Eighteenth Street into 50- by 110-foot lots—these would compose Fat City's most popular entertainment strip. By the late 1970s, the strip and surrounding area had plunged into a mess of massage parlors and seedy bars. The parish issued a moratorium in 1977 on new liquor licenses. The act also banned go-cups and increased police presence after underage drinkers began hanging out and committing crimes on the streets, which were crumbling, lacked proper drainage and strewn

with litter. In 1981, five massage parlors opened. Between 1982 and 1983, there were 137 arrests for prostitution. In 1982, Fat City Avenue reverted back to its original name. But Bob Tonti's apartment empire had grown to seventy-five hundred units.

Then there were more fires. In April 1983, Sancho Paza's on Eighteenth Street was heavily damaged. In the same week, Fletcher's Nitery burned one block away. In August, an apparent arsonist went on a spree, setting three fires that were reported within nine minutes—one in the 3300 block of West Esplanade and two in the 3400 block of Edenborn. Perhaps as a good example of the tawdriness into which Fat City had descended, in 1984, topless shoeshine "girls" awaited patrons at Fat Jimmy's bar. Fred Schulman, owner of Pearl's Place, said in 1985, "I think it [Fat City] was a big fun Las Vegas-like myth. It was like a big fireworks thing. It shot up and exploded and then died."[14]

As the *Times-Picayune*'s Patricia Behre reported on September 15, 1985, a former frequenter of Fat City described it as "kind of a dead zone" for nightlife. The Crystal Palace/Playboy Club was converted into Corporate Plaza in 1981. The Place Across the Street was gone. A newly formed Metairie Central Businesses District had been formed, replacing the clout of the old FCBA and seeking to rebrand the area as the Metairie CBD. The parish closed eight massage parlors and rezoned the area as a business core district, which would limit lounges with exotic dancers, tattoo and massage parlors and adult bookstores. Behre also gave us a look back. Her interview with Murray Solow, the first PR man for Fat City, brought us his recollections of visits with Connie Francis and Ed McMahon as well as his organizing of Miss Fat City pageants from 1973 to the final one in 1983. Behre also interviewed Klara and Drago Cvitanovich, who recalled rabbits and raccoons in their restaurant parking lot. "We've been here before Fat City [since 1968]," said Klara.

By 1988, Sancho Panza's was converted into an office building. The Spanish Galleon was a production studio. The Place became a children's uniform and costume shop. Jim Chehardy opened a restaurant in the Petroleum Club Building. But perhaps nothing better exemplifies the demise of Fat City as a nightlife haven than the 1990 proposal by Councilman Robert DeViney Jr. to build the Jefferson Parish morgue in the 4100 block of Hessmer Avenue, on the site of two run-down fourplex apartment buildings.

In 2007, the last of the big-time Fat City nightclubs closed in what had been the Godfather and Southside on the main strip at 3012 North Arnoult Road. In 1981, Kenneth John Vincent partnered with his father to buy

Left: The Fat City Snowball stand in later years. *Ronald LeBoeuf, TP.*

Below: John DeVun, co-owner of Fat City Snowball stand. *Ronald LeBoeuf, TP.*

Southside. He changed the name several times through the years: Kenny Vincent's Southside, Kenny's Key West, Vinyl, then back to Kenny's Key West. A master of promotions, he staged olive oil, midget and spaghetti wrestling as well as male reviews, wet T-shirt contests, chicken drops, 5:00 a.m. barbecues (he sold sunglasses for those who would leave in the morning sun) and Hip-Hop Saturday nights, to name a few. Large crowds also attracted trouble—a prostitution bust, violence, underage patrons and narcotics arrests. Between 2001 and 2007, police were called to the club 260 times. From 2003 to 2007, there were two murders, four nonfatal shootings, two armed robberies and several drug-related incidents. A June

2007 shootout resulted in two injured after more than fifty shots were fired. Five people were shot in August 2007 when two thugs opened fire near the dance floor. The Jefferson Parish Council took swift action to revoke the club's liquor license. Vincent opted to surrender it before this action could be taken and closed the last of the old Fat City hot spots.

1970s

INTRODUCTION

In 1970, Beulah Ledner opened a bakery on Metairie Road and kids first cavorted at the Trampoline Jump Center on Vets. Lakeside Hospital moved to Clearview at I-10 in 1971, and Sid-Mar's and Tony Angelo's opened in 1972. The following year, Jefferson Parish voters approved a twenty-year, $5 million bond issue for the purchase of the 77.5-acre Jefferson Downs for the building of Lafreniere Park. Also in 1973, the Crash Landing opened on Causeway. In 1975, Jefferson Parish marked its 150[th] anniversary.

STEINWAY LOUNGE (1959–1971)

When William "Bill" Barattani opened his lounge in 1959 at 8923 Vets almost to the Kenner line at the end of the highway, he had a problem:

> *Right off the bat, I start losing tremendous money at the Steinway. All we had was a dance floor. Beautiful terrazzo floor with a star on it. Cost a lot of money, terrazzo. I'd book the bands for Friday and Saturday night, but the parish is burning garbage at the incinerator on David Drive all weekend! I had a ditch in front my place, and everybody used to drive in it at night 'cause the fog was so bad. But it wasn't fog! It was smog! From the incinerator!*[15]

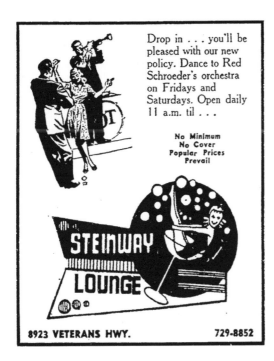

Above: A November 9, 1968 ad for the Steinway Lounge. *TP*.

Left: This July 14, 1962 ad reminded all that "Popular Prices Prevail" at the Steinway. *TP*.

At any rate, the Steinway had a good run. The neon sign out front depicting a "lady" lounging inside a martini glass could cut through any haze to attract drivers from the desolate road. And the sign on the lounge itself shone largely and brightly through the dark—a woman's hand clutching a second martini. Barrattini said the sign came from Ched's Lounge on Canal Street, where he had led the house band for years after playing drums on Bourbon Street with the likes of Pete Fountain and the Dukes of Dixieland.

Through the years, Barrattini hosted bands such as the C Notes, the Saxons, Freddie Domino, the Contours, the Bachelors and even the Inkspots. It was at the Steinway where an annual installment of the Mayor of New Orleans Posse was celebrated. In the early 1960s, he ran for the office of mayor of Kenner when he was the "King of the Steinway."

Barrattini sold the Steinway in 1970, and it lived for another year. In 1973, the building was remodeled to become the Pontchartrain State Bank. At the turn of this century, a seventy-year-old Barrattini planned to open a new high-class Steinway Lounge in Eureka Square on North Arnoult, a Fat City shopping center that he owned (and had built in the mid-1970s). This dream never came true. Bill Barrattini passed away on July 13, 2010.

Lakeside Hospital (1964–1971)

Dedicated on Sunday, December 6, 1964, at 1825 Veterans at Bonnabel, the privately endowed Lakeside Hospital for Women and Children employed twenty-seven doctors and an additional staff of twenty-five with plans to expand from serving maternity patients and babies to offering full medical services to women and children. Dr. Alvin H. Lassen served as the board of directors of the $300,000 facility. In 1971, the forty-two-bed hospital expanded by moving to its current location at Clearview and I-10, a $4.5 million complex.

Frank's Skating Palace No. 1 (c. 1971–1973)

Frank DiMarco had a rink at 5105–07 West Napoleon. This would later be the home of Key Color Lab. The rink moved to Indiana Avenue in Kenner.

BARNETT'S FURNITURE STORE (1960–1973)

Barnett's presence in New Orleans dates back to 1915. In 1960, a suburban outlet opened at 6303 Airline. In 1978, Pat's Furniture store moved into the building, which is now gone. This is now the location of the Zephyr/Baby Cakes baseball complex.

THE TUNNEL (1960–1970S)

Many Old Metairie "kids" remember the tunnel under the tracks on Loumar at Magnolia Avenue. It was formally dedicated by Jefferson Parish on March 31, 1960, at a cost $43,000 to construct, 15 percent of which was paid by the Southern Railroad, whose tracks it burrowed. Designed for pedestrian egress to Metairie Playground, the gated tunnel often flooded, and vandals destroyed its pumps. It was locked in the 1970s. In the aftermath of Hurricane Katrina, floodwaters from south of the tracks poured through the tunnel to the north side. The tunnel is now used to convey street drainage from the north side to Metairie Playground's retention ponds.

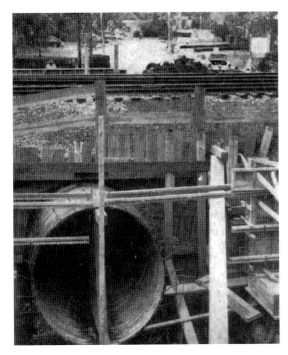

This 1960 photo shows construction of the tunnel under the railroad tracks on Loumar at Magnolia Avenue. *JPYR.*

Hopper's Drive-Inns (1961–mid-1970s)

In 1948, Patience Thomas and Phillip Paul Hopper opened an ice cream shop on Scenic Highway in Baton Rouge. As business grew, Hopper's drive-in offered what only upscale burger joints serve today: good beef freshly ground, potatoes peeled in-house for curlicue fries and ice cream made on-site and served in frozen glassware. Carhops ran to and fro, and re-orders could be had with a mere flash of headlights. Cars were loaded with teenagers and young families whose children might be clad in pajamas. The popularity of the first Hopper's led to its growth in 1953 to three Baton Rouge locations and six in other areas.

In 1961, Thomas's son Joseph "J.L." Mallett opened the first of the GNO locations at 1325 Jefferson Highway in a newly built, 135-by-400-square-

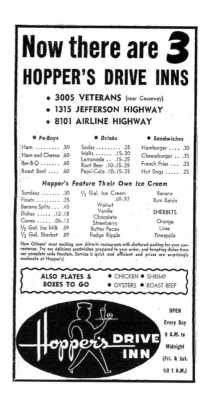

The August 4, 1962 menu for Hopper's Drive Inn Metairie restaurants. *TP.*

foot restaurant across from Ochsner Hospital at a cost of $100,000. Mallett had already purchased property at 8101 Airline Highway at Trudeau Drive for a second area location, which opened in 1962, as did the 3005 Veterans Highway drive-in (two blocks east of Causeway Boulevard) and the second Vets location at 4933 Veterans near Transcontinental Drive.

Hopper's operation as a regional chain came to an end in 1964, when Dobbs House purchased all eight outlets for $764,000. J.L. Mallett stayed on as head of Dobbs's new drive-in division.

Few local businesses gained as much popularity in a relatively short life span than did Hopper's, which is still remembered fondly by thousands. By the mid-1970s, however, all of them were gone. Burger Kings are now located at all but the Jefferson Location—it is now Ochsner Health Center for Children.

Carhops brought food from a kitchen "equipped with radar range…an atomic age cooking miracle….Food cooked to perfection in seconds. This is a 'must see!'" exclaimed this 1958 advertisement. *TP.*

JC RESTAURANT (1958–1970S)

In 1958, John Charles Lambert opened "Metairie's Newest and Finest" JC Restaurant Drive-In Lounge at 601 Vets. It advertised "Sterophonic music for your entertainment" and a fully equipped bar manned by "master mixologists" Bennie Zimmerman, Cliff Icard and "Moose" Giacona. Being "Fully Air-Conditioned" was a plus back in the day, but "Unlimitied Parking Space" on Vets would be at a premium today. JC's was popular for years, eventually ditching the carhops. In the 1970s, Sevin's Restaurant took its place. This has also been the location of Ralph and Kacoo's, King's Buffet and Soho Asian Cuisine.

KREWE OF ZEUS ON METAIRIE ROAD (1958–1974)

A week after Metairie's first women's krewe rolled, the first men's krewe, Zeus, debuted on the night of Sunday, February 16, 1958. It was themed "The Realm of Mother Nature." Led by two searchlights, the king was pulled by a mule-drawn float. The parade included twelve bands, including the U.S. Marine, Army and Navy Marching Bands, twelve floats and the Sheriff's Posse. Lynn Gay Lorino was its first queen, reigning beside King (and parish councilman) William J. O'Dwyer. He was the owner of Gennaro's bar, where the idea for the parade was hatched by neighborhood regulars. The route began at Severn Avenue and Metairie Road, proceeded to the new Jefferson Parish Office Building reviewing stand (not far from the bar), then onto Bonnabel for eight blocks before U-turning back to Metairie Road and ending on Focis.

The krewe's first ball was held immediately after the parade at the Metairie Playground auditorium. While Zeus still parades, it no longer uses

Old Metairie for its route, having moved to Veterans Highway along with most other Jefferson Parish krewes in 1974. It returned to Metairie Road for one night, on the fiftieth anniversary in 2007.

CONSTANTINO'S PHARMACY (1956–1975)

Constantino's Pharmacy, with a twenty-one-seat soda fountain, opened on March 1, 1956, in the new Airline Park Shopping Center at 6501 Airline (across the highway from what is now La Salle Park). This new drugstore was twice as large as the original on Jefferson Highway (which opened seven years earlier) and had full-time cosmetologist Edith Welch available for consultation and beauty advice. The store sold toys, cameras, jewelry, gifts, household supplies and more. Owner and pharmacist Leo A. Constantino, past president of the Louisiana State Pharmacy Association, passed away in 1980. His pharmacy on Airline, which closed in 1975, is now Cathay Imperial Restaurant, which opened as Cathay Inn in the 1980s. Other businesses formerly occupying the property include Sam's women's clothing chain and South of the Border Mexican goods.

FUN TROLLEY (1964–1976)

Fun Trolley Amusement Games opened in 1974 at the old Ted's Frostop location at 3501 Vets at Severn (which was by then named Ted Sternberg's Trolley Restaurant) next to Lakeside Shopping Center. Its advertising stated "All games at the Fun Trolley are good, clean fun, nothing immoral, illegal, or offensive to anyone." The Trolley encouraged parents to "drop their youngsters off with us when they shop" at Lakeside. In 1977, Snoopy's Fried Chicken restaurant opened here followed by Pizza Inn, which had a long run until 1994, when Lager's bar and restaurant erected a new building on the site.

ZOOM CITY (1977)

Zoom City skateboard park was located on West Esplanade at the edge of Fat City in 1977.

WESTGATE DRIVE-IN (1965–1977)

Opening on April 29, 1965, the Westgate Drive-in at 8801 Veterans Highway near David Drive was touted in ads as "The South's Largest, Newest, and Finest," accommodating two thousand cars. This "Show Place of the South" featured automatic in-car speakers, a "deluxe concessionary" and a "fabulous playground for the kiddies."

Owned and operated by Ernest Landaiche in association with Joy N. Houck, whose Joy Theaters, Inc. operated it, the Westgate's screen was 80 feet tall and 135 feet wide and reportedly cost $500,000 to build. A second screen was later added. The drive-in closed in 1977, and its twenty acres, owned by the Charbonnet and Woodward Family Trust, remained relatively vacant until the 150,000-square-foot Westgate Center shopping complex was built in 1983.

After closing, Airline Bowl become the Tropicana, featuring Tina Turner on opening night, June 30, 1978. *TP.*

AIRLINE BOWLING CENTER (1962–1977)

The twenty-two-thousand-square-foot, twenty-four-lane Airline Bowl occupied three acres at 7401 Airline Highway (four blocks west of David Drive) when it was opened by Crescent Bowl, Inc. on April 7, 1962. It was the first in the South to offer "Automatic Sparemasters." It closed in 1977 to become the short-lived Tropicana nightclub, which was also used as a bingo parlor called Crescent Hall, then Crescent Center, Crescent Bazaar and Bingo Palace. In 1986, it was sold to Lions Enterprizes to become the Lions Club Bingo Hall.

KREWE OF HELIOS (1958–1978)

The Krewe of Helios became the first women's Mardi Gras organization to parade in Metairie, on Saturday, February 8, 1958. Having formed in 1956 and hosted balls since then, the ladies' first parade, themed "Colorful Mexico," included ten floats, nine school bands and the Sheriff's Posse. The circuitous route ran from 3900 Derbigny Street to Severn Avenue, then to Metairie Road, where the queen was toasted at the reviewing stand. The parade went on to Bonnabel and then to Socrates (now I-10), where it U-turned back down Bonnabel to Metairie Road, then to Frisco, Aris, Pink, back to Focis, Metairie Road and on to Hollywood. However, since it started an hour later than scheduled, the parade bypassed Bonnabel, to the chagrin of enthusiasts waiting there. Twenty years later, the krewe disbanded.

CHEEPSKATES (1979)

Owned and operated by former Tulane quarterback Steve Foley and health economist Bill Pettingill, Cheepskates outdoor rink was at 608 Metairie Road in 1979.

GRAND THEATRE (1942–1970s)

WELCOME to the newest, most modern theatre…the GRAND. It is pledged to bring to the residents of Metairie the best pictures that the motion picture industry has to offer…featuring your favorite movie stars, the latest news of the world and a wide variety of carefully selected short reel subjects. It is pledged to always maintain for itself a character of co-operation and will strive to higher goals of achievement in the field of entertainment. We invite you to enter and enjoy many evenings of happy adventure and pleasure in these comfortable, beautiful surroundings. We take pride in presenting this splendid theatre to Metairie and New Orleans.
—United Theatres, Inc., October 2, 1942[16]

Locals were thusly introduced to the Grand Theatre for its grand opening in 1942. Located at 2055 Metairie Road on the corner of Beverly Garden Drive, the little movie house (which appears much grander here) operated

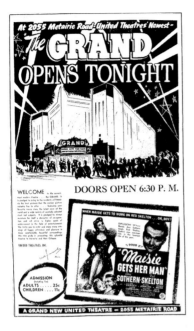

October 2, 1942, the opening night for the Grand Theatre. *TP.*

as a neighborhood show until the 1970s, when United Theatres's pledges were forsaken—"adult films" became the Grand's calling card. The theater was raided by the sheriff several times, followed by a civil suit to padlock the place. Ironically, the theater's location may have previously been the home of the Beverly Gardens nightclub, which sometimes ran afoul of the law due to its gambling operations.

Dolly Breaux, who grew up at 101 Dorrington Boulevard, just a hop, skip and jump from the Grand, remembers from her 1960s childhood "walking a half block on a Friday or Saturday night to pay $1 for a first run movie. It was safe so even at young ages, we could go by ourselves. Saturday matinees were 25 cents. We'd walk down to the Owl Food Store to buy candy and cokes to sneak into the show."

In the mid-1970s, the building regained respectability as the Harwick Veterinary Clinic. In 1988, it became the Little Red School House. United Theatres advertising writers would have been proud.

FROSTOP (1954–1970s, WITH THE EXCEPTION OF ONE METAIRIE LOCATION)

Locals loved Frostop's quarter-pound Lot-O-Burgers (made with fresh beef mixed with butter) and root beer served in frosted glass mugs. T.W. Ganus Company opened the first GNO location of the Ohio-based chain at 2714 Jefferson Highway. According to its last owner, Buddy Verrette, who acquired it in 2003, it was the location of the chain's first giant mug sign, which Ganus had designed and trademarked. Verrette closed it on January 31, 2007, when the destruction of the shopping center was impending. He moved his business to Destrehan, where he is still serving the original Frostop menu.[17]

ICY COLD DELICIOUS!
A NEW SPOT FOR
Frostop®
ROOT BEER
TRY IT!
BUY IT HERE
FROSTOP STORE
2714 JEFFERSON HIGHWAY
Distributed by
T. W. GANUS COMPANY
527 City Park Ave., N. O., La.
AU 1139 EV 2826

The first GNO Frostop opened in 1954 in the Jefferson Plaza Shopping Center. *TP.*

In 1955, the second local Frostop opened at 1900 Airline Highway near Williams Boulevard in Kenner. A Frostop opened across from Metairie High in 1956 at 1425 Metairie Road, but it became a Holiday Drive-in (think broasted chicken) from 1960 to 1966. This was later the location of Maurice's, Flambeau Flamin' Chicken, Casablanca and now Byblos. The Frostop at 5013 Veterans at Severn opened in 1958, two years before Lakeside Shopping Center was built. It closed in 1974. (*See* Fun Trolley, page 96.) The year 1958 also brought the opening of the 4637 Airline Highway location, a block from the three-year-old East Jefferson High School. It closed in the late 1970s.

There were seventeen Frostops in the GNO area in 1964. Today, there are only thirteen in the country, including the local restaurants at Clearview and West Metairie and at Calhoun and Claiborne Avenue.

1980s

Introduction

In 1980, the Do Drive-In closed, but R&O's and Houston's opened. Sales for De Limon Place condominiums began in 1981. Lafreniere Park opened in 1982 at what was the old Jefferson Downs. Old Metairie Village Shopping Center opened in 1985. Jimmy Swaggart was photographed with a prostitute outside the Travel Inn on Airline in 1987, and Paul Newman could be seen at the Sugar Bowl Courts filming *Blaze* in 1989.

Pelican Bowling Lanes (1961–1981)

At the New Orleans–Jefferson Parish line, the thirty-thousand-square-foot, thirty-two-lane Pelican Bowl opened on September 23, 1961, at 105 Veterans. It included a lounge, nursery, snack bar and billiards room. Built at a cost of $450,000 by Providence Land Corporation, the alley included $440,000 worth of equipment and furnishings. Consolidated Bowling Corporation held the lease.

Pelican Lanes hosted many bowling teams, but the most colorful was the Zodiacs of New Orleans, founded in 1969 by Linda Prattini. They traveled the country participating in United States Bowling Congress women's championships. The league banned pants, shorts and skirts shorter than one inch above the knee. In Prattani's words,

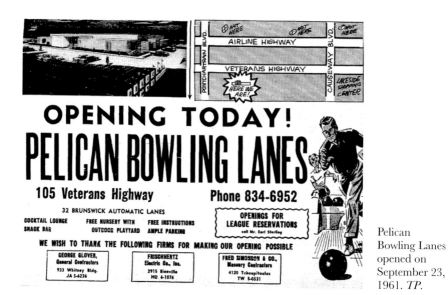

Pelican Bowling Lanes opened on September 23, 1961. *TP.*

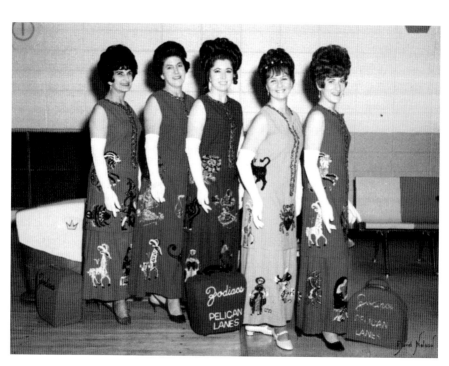

This 1969 photo shows the founding Zodiac members at Pelican Lanes: *(from left to right)* Frances Plaia, Anna Western, Linda Prattini, Mary Refre and Doris Matthews. *Gambit Communications.*

I was irritated with the fact that I couldn't wear slacks. The rules said how short your skirt could be, but not how long. I designed a formal to break away at the knees, and nobody knew that. We went to San Diego in high-heel shoes, long white gloves and did a modified strip out on the lanes as we unpeeled the bottom portion of our formals. It was just a rebellion against not being able to bowl in slacks. It must have worked, because two years later in Atlanta, we got to bowl in pant suits.[18]

In 2015, at the age of ninety-seven, Francis Loiacano Plaia was honored by the USB for bowling fifty consecutive years in the Women's Annual National Championships. She passed away on November 25, 2016, at the age of ninety-eight. In 2016, founding teammate Linda Prattini was so honored. Their uniforms now have a place of honor in the Louisiana State Museum and the International Bowling Museum and Hall of Fame. Pelican Lanes was demolished in 1981 to make way for Veterans Highway's tallest structure, the eighteen-story Heritage Plaza.

DE LIMON PROPERTY (1884–1981)

In 1884, German-born Peter Henry De Limon acquired the tract of land on the north side of Metairie Road between what is now Focis and Rosa Avenues. He farmed and grew oranges and shade trees at the Metairie Nursery and Metairie Ridge Nursery. At the time of his death in 1911, the nursery property spanned four hundred feet on Metairie Road by fifty arpents deep. A portion of the property was leased to the Marconi Wireless Telegraph Company of America in 1914. David Sarnoff, contract manager of the Gulf South Division and future president of RCA, oversaw the construction of this station. Its tower was located between Metairie Road and Metairie's Canal Street.

DE LIMON GREYHOUND TRACK (1927–1930S)

De Limon's son Louis became president of the Louisiana Greyhound/Kennel Club in 1926 and signed a deal to lease twenty-five acres of the property to the club for ten years at a cost of $65,000. A nighttime racing

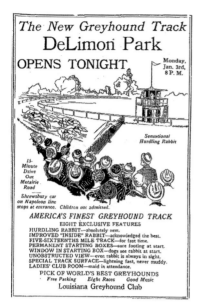

The New Greyhound Track
DeLimori Park
OPENS TONIGHT
Monday, Jan. 3rd, 8 P. M.

Sensational Hurdling Rabbit

15-Minute Drive Out Metairie Road

Shrewsbury car on Napoleon line stops at entrance. Children not admitted.

AMERICA'S FINEST GREYHOUND TRACK
EIGHT EXCLUSIVE FEATURES
HURDLING RABBIT—absolutely new.
IMPROVED "INSIDE" RABBIT—acknowledged the best.
FIVE-SIXTEENTHS MILE TRACK—for fast time.
PERMANENT STARTING BOXES—sure footing at start.
WINDOW IN STARTING BOX—dogs see rabbit at start.
UNOBSTRUCTED VIEW—even rabbit is always in sight.
SPECIAL TRACK SURFACE—lightning fast, never muddy.
LADIES' CLUB ROOM—maid in attendance.
PICK OF WORLD'S BEST GREYHOUNDS
Free Parking Eight Races Good Music
Louisiana Greyhound Club

De Limon Park greyhound track opened on January 3, 1927. *TP.*

track was to be built near the tower between the Metairie Kennel Club and the city. The greyhounds first raced at De Limon Park on Monday, January 3, 1927, but were halted in 1929 due to the same legislation that shut down the Metairie Kennel Club. The park was then used for occasional illegal greyhound competitions; picnics; pageants; carnivals; fairs; expositions; motorcycle, automobile and bicycle races; track meets; baseball games; political rallies; and more. In one of Bruce Boudreaux's wonderful interviews, Adele Illg Hertz, who was born in the 1930s and lived her life on the 400 block of Focis Street, recalled, "A cow field in the 300 block of Focis had a 4-foot-high hill that ran in a circle for blocks. That is where the dogs used to race. We crawled under a barbed wire fence into the field and played on broken and overgrown dog kennels, which were remnants of the De Limon dog racing track."[19]

GONZALES MOTORS (1932–1961)

This Ford dealership was located at 801 Metairie Road and operated by Sidney J. Gonzales, Sidney Jr., George B. Benoist and Acy A. Chiason. It later became Metairie Motor Sales, Metairie Ford and Lamberts of Metairie. In 1981, the sales office for the De Limon Place condominiums was located here.

ORIENTAL LAUNDRY AND A&P (1930s–1981)

The 1937 edition of the *Jefferson Parish Yearly Review* stated that the summer temperatures in Metairie were five to ten degrees cooler than in the city, due to its rural location. But it was well-enough populated that the national

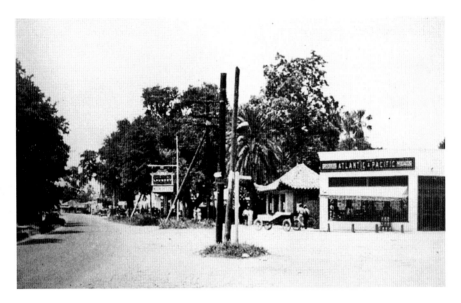

Metairie Road at Focis Street, 1937. Behind the tree at center was Hammill's Restaurant until 1954. It was later Chris' Restaurant and the Dixie Kitchen and bar. Gonzales Motors was just beyond. *JPYR.*

The Oriental Laundry at 703 Metairie Road operated here until 1962, when it moved to 705 and the Coffee Pot café moved in. *Maunsel White.*

grocery chain A&P opened a store at 701 Metairie Road, where it sold poultry feed and continued in this location until 1955 (when it was designated by the parent company as a "Super Market"). An Auto-Lec store was here in the 1950s and '60s, until Frank Sanzone opened the Metairie Market. Ninnette's Ceramics occupied the building in the early 1980s.

DO DRIVE-IN (1953–1980)

In 1941, a section of the De Limon property was subdivided for housing. De Limon Realty was chartered in 1955. In 1953, a landmark, still remembered, was added.

"Nowhere else can you see a cinema image that will compare in Depth, Scope, In Reality, with that of the DO." This first news of the new drive-in located at the front of the De Limon property at 805 Metairie Road appeared in the October 4, 1953 edition of the *Times-Picayune*, with the announcement of the "World's 2 Largest Screens" (135 feet in width), which would open on Saturday, October 10 with the New Orleans premier of *The Sea Devils* in Technicolor starring Rock Hudson ("a man built for actions") and Yvonne De Carlo ("a woman born to kiss"). Children under twelve were admitted free of charge when accompanied by parents who didn't mind their young offspring viewing "A female spy vs. Napoleon aided by a fighting man who tames her wildcat beauty." This would be followed by the film *Alaskan Eskimo*, also in Technicolor. Both films could also be viewed in the auditorium, which was equipped with stereophonic sound. Locals "did it at the DO" for almost thirty years until it ran its last B movie on August 21, 1980.

Adele Hertz remembered: "Henry De Limon lived in a house [one of the oldest in Metairie] on the west side of Focis Street near Metairie Road. He owned a string of rental properties on that side of the street. From there on back was nothing but woods and pecan trees. They bulldozed the woods to build the drive in."[20]

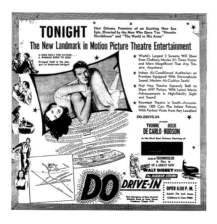

The Do Drive-In opened on October 10, 1953. *TP.*

Louis De Limon passed away in 1970, leaving his estate to his wife, Amy Dietz. At her death in 1974, her seven children inherited the property, which they sold in 1981 to John L. Crosby Sr. He demolished the businesses west of Focis Street to build the upscale Old Metairie Village Shopping Center and the exclusive De Limon Place condominiums.

AIRLINE DRIVE-IN (1950–1981)

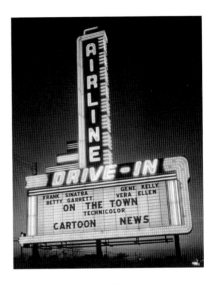

Airline Drive-In, photo by Charles L. Franck. *LDL.*

The "South's Newest, Largest, and Most Modern Drive-In," and the first in Metairie, opened on January 25, 1950, at 4000 Airline Highway at Cleary on land that had been Sportsman's Park auto racetrack. Operated by Woolner Theatres Inc., owners of Drive-In Movies (at 4000 Jefferson Highway), the new Airline boasted a seventy-foot-high, six-story screen ("largest screen in the South") that projected sixty-foot-wide views to as many as nine hundred automobiles with individual speakers. The double box office could admit four cars at a time, while popcorn and candy were "served by Airline Hostesses" in the knotty-pine refreshment room. Plans were in the works for a Kiddie Corral playground as well as a patio allowing for out-of-car movie viewing. The twenty-five-acre property was secured by a twenty-year lease. The drive-in closed in 1981.

PIK-A-PAK (1961–1980S)

Competing with Time-Saver, but coming some seven years later, the first Pik-A-Pak opened quietly in 1961 at 8935 Vets, across the highway from Massachusetts Avenue in a fifty- by forty-foot building with little else surrounding it. On March 11 of that year, the second location had a grand

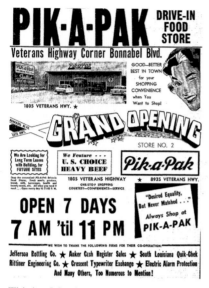

This is a March 19, 1961 grand opening ad for the second Pik-A-Pak. *TP.*

opening six miles down the highway at 1805 Vets at Bonnabel. In 1962, 5 more sprouted up in the GNO, including a third Metairie location at 2315 Vets. By 1963, Hugh K. Howton, president of Pik-A-Pak Grocery Corporation (headquartered at 2305 Vets), announced plans to expand from these 7 stores to 150 in the GNO, with 15 more planned in 1963 alone. He hoped to eventually employ 475 local people with a payroll of $2,225,000 at a cost of $3,225,000.

Howton's business plan was simple. He focused primarily on selling six items: milk, bread, ice cream, soft drinks, beer and cigarettes. These alone had already accounted for 70 percent of sales. Pik-A-Pak was not interested in competing with grocery stores but sought to fill the niche for fast self-service pickup goods. Other foodstuffs, including fresh meat, were offered for those who wished to add a bit more, especially during the hours when groceries were closed—he operated from 7:00 a.m. to 11:00 p.m.

Pik-A-Pak was marketed as a drive-in food outlet—a terrific idea in its place and time. In 1964, Pik-A-Pak became a division of Li'l General Stores. By the 1980s, all of the Pik-A-Paks were gone.

SHIRER CASKET COMPANY (1963–1980)

In April 1963, residents of the Metairieville Improvement Association protested the planned construction of a coffin-manufacturing business at 383 Lake Avenue. Cullen Schouest, Jefferson Parish Council chairman, explained that, although the area had been zoned Residential-2, it had been changed to Commercial-2 in 1959 and that the parish certificate approving of the business in that location had already been issued. Shirer Casket Company moved to Metairie in 1963.

The company had a long history in New Orleans. In 1914, Newton E. Shirer invested $75,000 in his new business at 400 Canal Street. Originally

from Zanesville, Ohio, he had moved to New Orleans in 1886 to oversee a local casket company and was eventually named its president. In 1952, Shirer moved to 830 Conti Street (now the Prince Conti Hotel). Irwin N. Shirer succeeded his father, who died in 1939, to become the company president. His brother Fred became the general manager.

In a 1976 *Times-Picayune* interview, Fred explained that the company made three types of caskets: hardwood, metal and cloth-covered (the biggest seller and the most affordable) with doeskin, velvet, felt or printed material. Sizes ranged from adult, at six feet, six inches by twenty-two inches wide, to infant, at one foot, nine inches by eight inches across. Custom sizes were available by special order. Gone from Old Metairie now, Shirer Casket Company moved its headquarters in 1980 to 1025 Harimaw Court between Airline Drive and the Earhart Expressway, just south of Metairie Country Club's golf course.

BEULAH LEDNER'S BAKERY (1970–1981)

I originated the doberge in New Orleans and they were a hit. It's a German word, but I changed it to sound French to give it more a local flavor....I made them in a butter cake dough with boiled custard layered fillings in vanilla, chocolate, and lemon flavors—in caramel, too, but that had to be ordered specially.[21]
—*Beulah Ledner, 1985*

Beulah Levy Ledner's grandfather was a renowned baker in Germany. She was born in 1894 in St. Rose and carried on the tradition. During the Depression, she began selling goods baked in her New Orleans kitchen on Hickory Street to supplement the income from her husband's furniture business. It was here that she replaced the Hungarian-Austrian dobos torta's butter cream filling with custard and named her business Mrs. Charles Ledner Bakery.

In 1933, the Ledners moved to a new home at 1200 Lowerline, where she used half the basement for baking and catering and the other half as a tearoom. In 1937, they opened a bakery at 928 Canal and soon after moved to 2721 South Claiborne. After suffering a heart attack, she sold the bakery, recipes and the name "Mrs. Charles Ledner" to Joe Gambino in 1946 under the condition that she not open a New Orleans location for five (some say ten) years.

In 1948, at the age of fifty-four, she remodeled an old A&P grocery at 2513 Metairie Road and opened Ledner's (Beulah Ledner Inc.). There she stayed for twenty-two years until outgrowing the place and moving in 1970 to 3501 Hessmer in Fat City. Mrs. Ledner retired on Mother's Day 1981, when she was eighty-seven years old. She passed away on March 30, 1988, at the age of ninety-four.

THE AEREON THEATER (1948–1982)

Opening on December 3, 1948, the Aereon was located at 3409 Metairie Road near Severn and Airline. Its first showing was a western, *Northwest Stampede*, starring James Craig and Joan Leslie. With one thousand seats and its location "in the center of a square, with surrounding parking spaces for patrons," the fireproof, air-conditioned theater offered "the latest RCA sound equipment" according to owner-operator Vernon Dupepe, who had formerly owned the Suburban Bowling Alley.[22]

In the 1950s, with other businesses filling the formerly large parking area, the theater address was changed to 3345 Metairie Road. During the 1960s, it became part of the Joy Theatre chain, which divided it to accommodate

—Staff photo by Donald Stout

THE JOY'S AEREON THEATER, 3345 Metairie store. The theater has been in the neighborhood since from shopping center theaters is driving small Road, is being torn down to make room for a drug- 1953. A Joy's Theaters Inc. official said competition movie houses out of business.

The old movie house under demolition, April 15, 1982. *TP.*

a second screen. A third screen was wedged into the original structure the following decade. In 1982, thirty-four years after opening, the Aereon was demolished to make way for a drugstore, which is currently vacant.

METAIRIE HOSPITAL (1946–1983)

Metairie Hospital at 310 Codifer was opened with thirty beds in 1947 by Dr. William Kohlmann Gauthier under the auspices of the New Orleans–Metairie Hospital Foundation. Twenty new beds were added in 1951, and the hospital expanded in 1953 with the addition of a two-story, thirty-six-bed wing designed "for the care of aged patients." In 1956, a "chronically ill wing" was added. By 1963, thirty doctors practiced here, and in 1965, a two-story, eight-thousand-square-foot wing included forty new beds. A $1 million expansion in 1967 brought the patient count to 130 under the care of sixty-five physicians. By 1969, Metairie Hospital's holdings stretched across the block to reach 1605 Metairie Road. In 1971, long-range plans to make it a complete medical complex were announced. A new outpatient clinic came in 1973, and an alcohol recovery unit was added in 1979.

Metairie Hospital's appeal as a modern and complete medical facility began to falter with the opening of Lakeside and East Jefferson Hospitals. The bed count shrank to 105. In 1981, Dr. Gauthier was forced to liquidate his holdings after a divorce settlement, and in 1982, the hospital was sold for $2.6 million to Omni Health Services in partnership with several local doctors headed by R. Alton Ochsner Jr., who was to be the chief of surgery. It was renamed Bonnabel Hospital, and plans included renovation, expansion and eventual replacement of the facilities. In February 1983, some three hundred opposing residents appeared before the parish council, which voted unanimously to block the hospital plans.

In 1984, Omni announced the ground breaking for its replacement facility, Elmwood Medical Center. The old hospital continued to operate under the names Metairie General and Bonnabel Hospital until 1987, when the sale of the two-acre tract was announced. The Charleston Park townhouse development, built by Dave and John Treen on the original hospital footprint, is now an upscale residential complex.

Weaver's Farm (1940s–1980s)

Samuel J. "Sam" Weaver was a boxing trainer, manager and promoter in the 1930s and '40s who turned his attention to training, breeding and stabling thoroughbred racehorses at Weaver's Farm by the lake. Located at 3940 Hammond Highway at Cleary, this was, likely, Metairie's first and only thoroughbred breeding facility. After Weaver died in 1974 at the age of sixty-nine, Gwendolyn Langridge and William Carraway acquired the property. By the mid-1970s, houses were cropping up nearby, but Leveeview Stables boarded horses and offered riding and jumping lessons here until the 1980s.

Woolco (1968–1983)

Straddling the Metairie/Kenner boundary, the "new and excitingly wonderful" Woolco Department Store opened its doors on Veterans Highway in 1968 just a block from the double-screen WestGate Drive-In. It was converted into Steinmart and House Works stores in 1983.

The Crash Landing (1973–1983)

Opening in May 1973 at 2645 Causeway Boulevard, the Crash Landing advertised as having landed "on the Gateway to Fat City," but it closed before the year ended. Jose Antonio Gonzales, a 51 percent owner, claimed that it had been taken over by mafia figures and that he was forced to sign over his share of the business to them. Carlos Marcello was tried for extortion but acquitted. Meanwhile, the nightclub operated as the Millionaire's Club and the 5 Star Playhouse. Through the years, it became the Crash Landing again; then (LeRoy R.) Fairman's, which featured stripping cheerleaders for NFL games and all-male revue ladies' nights; Scandals; Palladium; Flix; the Cartel; Metropolis; and Sal Saia's Beef Room. The plane was removed from the site in April 1983.

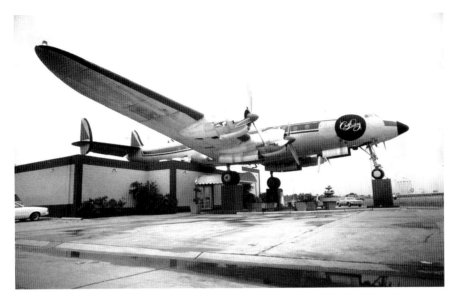

A Lockheed Constellation was a component of the Crash Landing. Patrons entered the plane by way of stairs inside the building. *Chris Protopapas*.

PAPWORTH TRACT (1901–1984)

Metairie Ridge Nursery

In 1901, Harry Papworth bought the equivalent of six blocks fronting Metairie Road (now Carrollton to Avenue A) extending to the lake—a total of about two hundred acres—for $4,000. The English horticulturist built his home there, planted oak trees along the road and started the Metairie Nursery Company on twenty-five acres. In 1905, he and investors established the Metairie Ridge Nursery on an additional two hundred acres. It seems likely that he and De Limon were early partners in these businesses.

After his death in 1943, Papworth's daughter Ann Elise took over the business and managed it until her death in an auto accident in 1957 at the age of fifty-four. In August 1963, her brother, then vice president of the firm, died at the age of fifty-four after an extended illness. On December 1, 1963, the businesses closed.

Ann Elise Papworth's home at 315 Metairie Road, having fallen into disrepair after years of neglect by a different owner, was demolished to make way for the Old Metairie Villa office condominium in 1984; sixteen

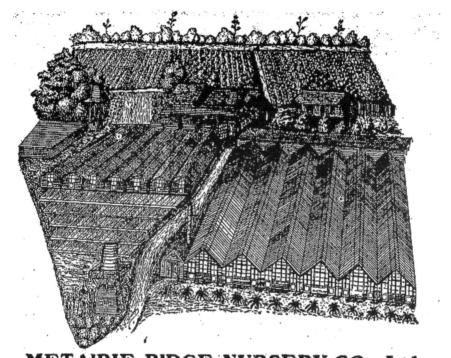

METAIRIE RIDGE NURSERY CO., Ltd.

Grand Exhibition of the Finest Display of Roses, Carnations and Chrysanthemums ever seen in New Orleans.
Come and see the Most Modern Establishment for the growing of Cut Flowers and Plants in the country.

An October 29, 1905 advertisement for Metairie Ridge Nursery. *TP.*

of the oaks that Harry had planted were spared. The nursery office at 401 Metairie Road is now the the Metairie Towers condominiums and office building.

Metairie's First Parade

In September 1910, a group of prosperous businessmen formed the Metairie Road Commission with the goal of improving the rugged country thoroughfare. The panel included Harry Papworth, Robert Bensberg, Peter Buchler and Conrad Buchler. Without compensation and with the approval of the police jury, they would collect five cents per front foot from property owners, and the parish would match the funds collected. The commission was given full discretion in planning and implementing

the road. Improvements planned included street lighting, sidewalks and landscaping. The police jury at this time asked property owners to drain Bayou Metairie as part of the "improvements."

By February 1911, the commission planned a "formal opening" of Metairie Road, an event to which they would invite the governor of Louisiana and the mayor of New Orleans and that would culminate with a parade of carriages and automobiles. This event took place, in a much-scaled-down version, on March 5 as a meeting at the Metairie Ridge School to discuss the commission's progress and other pertinent issues of the day, a parade down the road via buggies and autos and a party hosted by Papworth at his nursery.

Papworth Subdivisions

In 1915, Papworth developed the Metairie Ridge and Metairie Nursery subdivisions. Eventually, most of his land was converted to residential housing. Horticultural street names from the lake to Metairie Road now let us know the extent of the old nursery: Live Oak, Ash, Poplar, Chestnut, Lilac, Rosebud, Cotton, Pine, Cherry, Walnut, Raspberry, Vine, Lemon, Mandarin, Rose, Violet, Hyacinth, Narcissus, Forest, Wood, Dahlia, Grenadine and Nursery.

DELERNO'S (1920S–1985)

In the late 1920s, when Metairie Road was yet unpaved and undeveloped, Frank Joseph Delerno operated a soft-drink stand at 619 Pink Street at Focis, just off the main road. He offered more than Cokes, as a 1929 raid of a speakeasy at that location revealed customers gambling and drinking beer, wine and cocktails in several private rooms. Some sixty years later, the third generation of the family was still operating there.

By 1952, Delerno's was advertising as "One of Metairie's Largest and Oldest Restaurants," serving French, Italian and Creole food under Frank's ownership and the management of his son Joseph "J.B." After J.B. passed away in 1980, his sons Joseph "Jay" Jr. and Darryl took the helm, buying the business in 1982 from their mother, Melba Walker Delerno. She stayed involved in the restaurant until 1985, when Stanley Chaisson opened

Chaisson's restaurant here. The Delerno name returned in a place run by J.C. Leblanc and chef Larry Lindelow in 1990.

J.B. Delerno was a founder and chairman of the New Orleans Food Festival, past president of both the New Orleans and Louisiana Restaurant Associations and an avid Saints fan. Here is the story Melba and J.B.'s son Jay Delerno tells of his dad's devotion to our football team:

> *If you looked at the front door of Delerno's Restaurant, next door on the right side was the house where Pop Masson, also a restaurant owner, and his family lived. The Masson home was replaced years later by the two-story bed-and-breakfast in the same location.*
>
> *In the mid 1960s, JB Delerno was the president of the Louisiana Restaurant Association. In 1966, when New Orleans was awarded a pro football team and it was named the Saints, J.B. Delerno and his friends next door, Ernie and Albert Masson, decided to offer the Saints a mascot that could make its debut in the opening game.*
>
> *They decided on getting a Saint Bernard. After searching around, they found a perfect Saint Bernard in the Pacific Northwest (either Oregon or Washington State). And surprisingly, the owners donated the dog. JB and the Massons decided to name him Gumbo, in true New Orleans tradition.*
>
> *For all of his life, Gumbo #1 was housed next door to Delerno's Restaurant, in the Massons' backyard. Both the Delernos and the Massons took care of Gumbo #1. Delerno's customers would many times stop next door to visit Gumbo.*

In 1993, the Little Greek restaurant moved into this building. The site was later occupied by Kokopelli's (1997), SunRay Grill (2005) and Conola Grill and Sushi Bar (2116). *Infrogmation.*

J.B. Delerno was Gumbo's handler, and he was always the one who brought the dog to the Saints games and tended to him on the field.

If you went to Delerno's Restaurant during those years, you saw that the room on the immediate right inside of the entrance door was named the Gumbo Room. The walls were papered with pictures of Gumbo #1.

MEYDRICH'S FINE FOODS (1959–1985)

Frank Meydrich owned Meydrich's Fine Foods at 1405 Vets at Homestead, as well as Venice Gardens Super Food Market on South Claiborne. He served as president of the Louisiana Retail Food Dealers Association and was a board member of the French Market Corporation and the New Orleans Terminal Market Board, which sought unsuccessfully to build a hub in Metairie for grocery commodities and produce.

In a 1962 meeting of retailers from across the area who discussed a growing crime wave of armed robberies, Meydrich said, "So far it's only been money, but one day it's going to be a life."[23] Eleven years later, on July 6, 1973, he was shot and killed in an armed robbery attempt two blocks from his New Orleans store. The Metairie store was replaced by a pharmacy.

SCLAFANI'S (1958–1985)

Peter Sclafani bought land in Metairie on a dirt road in 1947. Fifty years later, he sold it for $500,000. In the meantime, he operated one of the most successful and beloved restaurants in the area there. Restaurant Sclafani at 1301 Causeway opened in 1958 in a big red-brick building that could seat 500, employed 150 and became a landmark where families celebrated weddings, bridal showers, business and club meetings, banquets and special nights. Mario Lanza, Rock Hudson and Roy Rogers dined there.

Sons Frank and Peter Jr. learned the trade there under their father's guidance. Frank became executive chef after Peter's death in 1977. After Sclafani's closed, Frank opened Sclafani Cooking School on nearby Gennaro Place. Peter Jr. struck out on his own at Hayne Boulevard, where he owned and operated Sclafani's Restaurant and catering hall. The big red building was demolished in 1997. It was replaced by an animal hospital.

A May 20, 1960 ad celebrates the fortieth anniversary of Jefferson Bottling Company. *TP.*

JEFFERSON BOTTLING COMPANY (1920–1987)

Irbin Pailet, with one horse and a wagon in 1920, built an ice and soft-drink empire. The family business included Metairie Ridge Ice Company at 308 Labarre Road. On May 20, 1920, the Jefferson Bottling Company was established at 716 Frisco Avenue at Metairie Road.

In 1928, Irbin bought the Orange Crush bottling company at 3500 Tulane Avenue. Ten years later, the Pailets introduced Big Shot Root Beer. During the 1940s, lithium-laced, lemon-flavored B-Up was introduced as a 7-Up competitor. Meanwhile, the Pailets opened icehouses all over town. By 1960, the bottling company alone employed one hundred people at its plant.

In 1982, the company was sold by Sara Pailet to a group of investors led by Robert Cory, who became president and continued to produce the soft drinks. On Monday, June 1, 1987, the bottling division was sold to Affiliated Food Stores, Inc. of Little Rock, Arkansas. Big Shot sodas—pineapple, strawberry, cola, black cherry, cream soda, orange, fruit punch and grape—would be bottled in Winnsboro, Louisiana.

OLD METAIRIE LIBRARY (1949–1988)

The first Metairie branch library was opened on Friday, December 2, 1949, at 3404 Metairie Road, but in May 1951, the Metairie Regional Library formally opened at noon at 100 Atherton at Metairie Road. By the late 1980s, the lovely Arts and Crafts building was considered outdated and much too small for a branch with the largest circulation in the parish. On Monday, July 11, 1988, the new and modern Old Metairie Branch opened just down the street at 2350 Metairie Road and Glendale Drive. It was the the first fully automated library in the parish. The beloved old

place has since been converted into an art center, then a sign company and now a children's clothing store.

Sena Mall (1968–1989)

For twenty-one years, the single-screen Sena Mall Theatre stood at 714 Elmeer Avenue at Veterans Highway. The building remains, now the location of Martin Wine Cellar. Opening on March 27, 1968, as a Walter Reade theater, it was taken over by Gulf States Theatres in 1977 and then by United Artists in 1986.

Sena Mall closed on May 7, 1989. The single-screen theater could no longer compete with megaplexes. In its waning days, it had become a dollar-show venue, but for many years and until the end it was a popular venue for fans of the cult favorite movie *The Rocky Horror Picture Show*, which reportedly ran for 1,320 midnight shows here.[24] In June 1978, the movie became the Sena Mall's Friday and Saturday midnight movie, and a tradition was born. The Sena Mall became a gathering place for hundreds of outrageously clad young people who began assembling in the parking lot on weekend nights beginning around 10:30 p.m. They were mostly underage drinkers of Boone's Farm wine and beer purchased from the Time-Saver convenience store adjacent to the theater. When the party moved inside, employees and off-duty Jefferson Parish deputies looked the other way.

Then began the audience participation: wisecracks shouted from costumed viewers, rice thrown during the wedding scene, melba toast flung about, water pistol shooting, cigarette lighters flicking, toilet paper hurled, viewers dressed as cast members acting out the story in front of the screen and a motorcycle driven into the theater when Eddie the biker (played by Meat Loaf) rode in during the film. This went on for eleven years. As one crowd of *Rocky Horror* regulars lost interest in this ritual, a younger group emerged to continue the tradition. Shortly before the Sena Mall closed, the last *Rocky Horror* viewing took place on May 6, 1989. The move and the crowd moved to Lakeside Theatre for a while, but the magic had been lost.[25]

1990s

INTRODUCTION

Al Copeland's Christmas lights moved to the state capital in 1990. Celebration Station opened in 1992. Two years later, Lager's bar opened at Metairie's first Frostop location. The Saints moved their practice facility to Airline in 1995. The Walker-Roemer cow was removed from her perch along the I-10 in 1996. In 1998, Hurricane Georges spared the city but did tremendous damage on the lakefront and in Bucktown.

BORDEN'S (1949–1991)

In 1949, the Borden Company built a colonial-style office and retail outlet as well as a large processing plant at 1751 Airline Highway near Ridgewood Drive at a cost of $600,000. From there, Borden packaged milk, cream, cottage cheese, yogurt and ice cream for distribution throughout the GNO via a large fleet of vehicles during an era when milkmen made daily runs.

When the facility opened, "Bordon Week in New Orleans" was declared to begin on Monday, March 7, 1949. The week included the dedication of "America's most beautiful Milk and Ice Cream Plant" with its "Graceful Plantation-Type Building." Best of all, perhaps, was the prospect of knowing that "Beauregard and I [Elsie the cow] will be in our special boudoir."

The $600,000 Borden's dairy on Airline, 1951. *JPYR.*

Borden's ceased production here in 1988, but the staff remained on hand until 1991, when the facility was completely shut down and the plant was demolished.[26] David and Tommy Crosby's 21st Century Development Corporation, which had built the De Limon condominiums eleven years earlier, purchased the property in June 1998 and built forty-two townhouse units on the 3.2 acres, naming the development Old Metairie Place. Hurwitz Mintz Furniture now occupies the Airline Highway frontage.

METAIRIE HARDWARE (1929–1993)

A sign near the road points the way to Delerno's in the accompanying 1937 photograph of the "Metairie Community [shopping] Center," the first

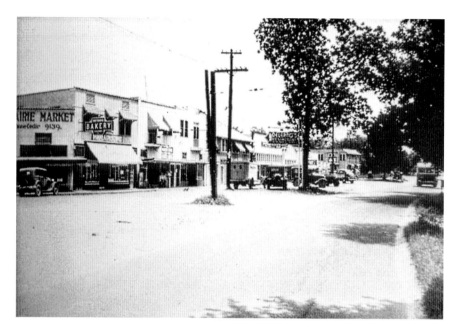

Metairie Community Center, 1937. *JPYR.*

strip mall in Metairie, built in 1929 on Metairie Road between Frisco and Focis. Through the years, Metairie Hardware was located at several of these storefronts until it was partially demolished in 1993 and replaced with a new building. Longtime owner Warren Edward Gambino was also a cofounder of Gambino's Bakery.

PUTT-PUTT ON VETERANS (1966–1993)

Putt-Putt miniature golf opened next door to Hopper's at 4901 Veterans in 1966 and remained there for almost thirty years. A game room was added in 1981. After tough competition with Celebration Station, which opened nearby in 1992 with three miniature-golf courses and a plethora of other attractions, the last putt was sunk here on August 31, 1993. The land Putt-Putt occupied on the now bustling highway was of more value than the business. It was replaced with Ochsner Children's Health Center.

The Saints' Second Home

Archie Manning is featured in this
1973 ad for the Saints practice facility
at 6928 Saints Drive near Airline.
JPYR.

SAINTS PRACTICE FACILITY ON DAVID DRIVE (1967–1995)

In 1967, within a year of becoming an NFL franchised team, the New Orleans Saints purchased and began practicing at their training facility a block off of Airline Highway between David Drive and Eisenhower Avenue. The five-acre facility was built at a cost of $464,000, and the parish designated the street leading to it as Saints Drive. In 1995, a two-alarm fire severely damaged the main building.

The Louisiana legislature approved a new practice facility in 1993. Ground-breaking ceremonies were held in 1995 for the current site at 5800 Airline Drive.

TRAMPOLINE JUMP CENTER (1970–1995)

In 1970, retired engineer Lloyd Tabary opened a trampoline retail and jumping business at 1620 Vets near Bonnabel. For twenty-five years, local kids bounced and flipped and then, eventually, brought their own children here. Trampoline Jump Center closed in 1995, when the owner of the property decided to sell. A gas station now occupies the property.

HOUSE OF LEE (1959–1995)

House of Lee was opened in 1959 at 3131 Vets near Causeway by Chinese immigrants Bing Lee and Yip Shee Lee (parents of Jefferson Parish sheriff Harry Lee). They first operated a laundry on Carondelet Street. The popular restaurant served Chinese and American food "in Chinese Atmosphere" until 1995. After almost thirty-six years in business, second-generation

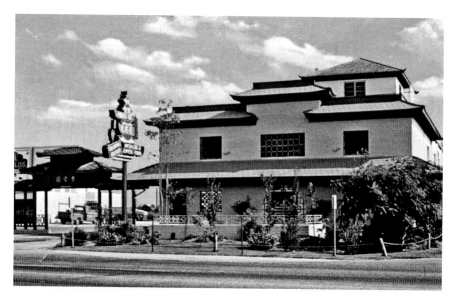

Undated House of Lee postcard. *AC.*

proprietors, brother and sister Davis and Virginia Lee, decided to retire. They and their six siblings sold the property for $1.75 million. The iconic building was demolished and replaced with a Borders bookstore.

PARADISE LANES (1959–1995)

There was a lot of construction on Veterans in the early 1960s. The combination of burning debris to make way for construction and fog made it almost impossible to drive down Veterans, so I parked [at Lakeside Shopping Center, five blocks away] *and walked several blocks to the alley. It was 6 in the morning, but Paradise had a $2 special for four hours of bowling then.*
—*Ruth Martin, wife of Paradise Lanes co-owner Emile Martin*[27]

In 1959, Emile Martin and Frank Simone formed a partnership with eight others to build Paradise bowling lanes at 3717 Vets. Opening with twenty lanes and a waiting list to bowl at midnight, the facility added fourteen lanes the following year. Automatic scorers were installed in 1969. For thirty-six years, thousands of bowlers played in hundreds of leagues before Frank Simone opted to close the alleys and lease the property to Barnes & Noble

Booksellers. The last pin fell on September 10, 1995, and the building was demolished. Remnants of Paradise live on in the tabletops of the coffee shop inside the bookstore, which are constructed of wood from the lanes.

PATIO THEATER (1950–1959) / JOY'S PANORAMA (1967–1996)

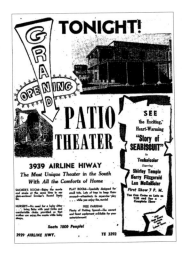

Grand opening of the Patio Theater, January 26, 1950. *TP.*

"The Most Unique Theater in the South with All the Comforts of Home" boasted a January 26, 1950 *Times-Picayune* advertisement announcing the grand opening of the Patio Theater at 3939 Airline at Cleary. Unique features included a glass-enclosed smoking room accommodating fifty moviegoers, an infant nursery with cribs for babies and chairs for mothers, a toddler playroom with attendants and valet parking. The one-thousand-seat facility's exterior was designed to emulate Vieux Carré–style balconies. The Technicolor film *The Story of Seabiscuit* starring Shirley Temple was the opening-night feature.

Joy Newton Houck of the Joy Theater chain later bought the business in 1959, when his Panorama theater at Baronne and Gravier Streets was scheduled for demolition. He planned to move the Todd-AO wide-screen projection equipment from there to the Patio. However, by 1960, Houck opened the forty-lane Joy's Bowling Center at the Metairie location.

In 1967, Houck converted the property back to a theater, opening the 1,060-seat Joy's Twin Panorama I and II, whose "decor throughout the theater is a 'mod' takeoff from the movie 'Casino Royale'" and "thick carpeting in the lobby resembles a Mondrian painting," At this time, Houck reportedly owned sixteen theaters in New Orleans, Arkansas and Texas (including the Robert E. Lee Cinema in Lakeview).[28]

By 1970, two more screens were added, and in 1985, a total of six screens were contained here. Houck sold the business to Movies Inc. in 1993, which operated it from 1993 until 1996. A fire led to the building's demolition in 1999. The structure was replaced with an AutoZone.

SCHWEGMANN'S (1869–1996)

The original Schwegmann's Grocery and Bar was founded in 1869 at the corner of Piety and Burgundy Streets in New Orleans's Ninth Ward. It was the first grocery in New Orleans to offer self-service shopping—when it was introduced, customers could opt for full or self-service (at a 10 percent discount), but self-service became the norm, much to the customers' liking.

The German-born founder's grandson John Gerald was born above the store in 1911 and began working there full time in 1939. By 1946, John G., with his brothers Anthony and Paul, opened Schwegmann Brothers Super Market at 2222 St. Claude Avenue near Elysian Fields.

In 1951, the brothers invited all to "Follow the Crowds to the Store that Has the Lowest Prices in Town"—their first suburban location, at 2701 Airline at Labarre. Schwegmann Brothers Giant Super Market offered a unique (to Metairie) experience, in which one could grab an oyster loaf and a beer (at Shopper's Bar, Incorporated) to carry down the aisles while making

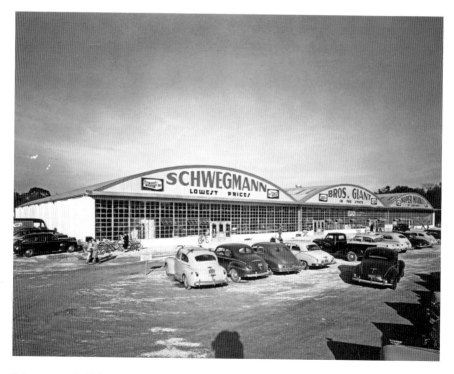

Schwegmann's Airline store. *LDL*.

groceries. The cavernous store was not air conditioned, but it was fronted with windows and topped with large roofing vents above an unfinished ceiling. Across the front of the store was written "LOWEST PRICES IN THE STATE OF LOUISIANA."

With the introduction of the giant supermarket concept, New Orleanians were offered a Walmart-style store long before the big boxes existed, offering groceries, fishing gear, sporting goods, school uniforms, toys, electonics, appliances, fresh-baked goods, liquor (including Old Piety & Burgundy brand), jewelry, clothing, in-store bars, raw oyster bars, gasoline and more. To top it off, paper grocery bags from Schwegmann's routinely endorsed politicians—including John G., his son John F. and his daughter-in-law Melinda, who all held public offices.

Metairie's second Schwegmann's (the fourth in the GNO) opened at 3620 Veterans Highway on December 12, 1960, across from the new Lakeside Shopping Center. A featured attraction was "year-round air-conditioning." The eighth Schwegmann's location opened at 8001 Airline Highway (between Trudeau and North Howard) on March 17, 1969. On May 17, 1982, the Bissonet Plaza store at 3711 Power Boulevard opened.

In the 1980s, in an attempt to make an old business seem new again, John Gerald's son John F. announced plans to renovate all fourteen GNO storefronts with Spanish-influenced arches and to replace his father's classic neon "Schwegmann Bros. Giant Supermarket" signs with his modern, backlit, italicized logo reading simply "Schwegmann." Beginning in the late 1980s, he began acquiring Sav-A-Center, That Stanley! and Canal Villere stores. But he stretched the grocery empires aspirations too far. In 1996, all eighteen Schwegmann stores, along with twenty-eight newly acquired National stores, were sold. At its peak, the chain included forty-six locations.

The Airline at Labarre store was demolished in 1999 and replaced with a Sav-A-Center. The store at Airline near Trudeau is now Bent Marine. The Veterans Highway location was demolished to make way for a Lowe's Home Improvement Center. The Power Boulevard store is now a Rouses.

WALKER-ROEMER DAIRY & COW (C. 1918–1996)

Lakeside Dairies began around 1918, and Roemer Dairy Products started up in Metairie during the 1930s. By 1946, Charles E. Roemer operated both the Roemer and Lakeside Creamery. In 1943, Roemer's was at 5101

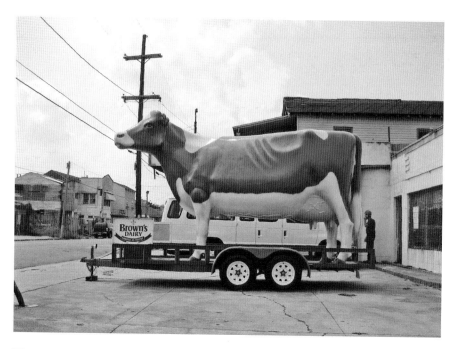

The old cow parked at Brown's Velvet Dairy on Baronne Street, 2008. *Infrogmation.*

Airline at Carnation. In 1951, it became Walker-Roemer Dairy. In 1959, the property was for sale and became a McDonald's location in the early 1970s. In 1957, the dairy moved to 5201 Airline. The cattle and dairy were gone by 1963, when Alto Trailer Sales moved to the location, to be replaced by M&L Industries in 1977.

In the early 1960s, before the I-10 came through, Walker-Roemer moved to a four-acre property at 2800 Richland Avenue between Clearview and Cleary and built a twenty-five-thousand-square-foot facility. In 1962, the company introduced drip-proof cartons and discontinued the use of traditional milk bottles.

The company erected a twelve-foot-high, eighteen-foot-long revolving cow perched atop a thirty-five-foot pole. It became a Metairie landmark. The cow was adorned with a wreath for the holidays and a Mardi Gras flag for the carnival season. It was considered bad luck if her tail spun in a car's direction while one passed it on the Interstate. It was beloved, but also a victim of sport, riddled by ten bullets and spray-painted.

In October 1993, Barbe's Dairy purchased the business and the unnamed cow, but not the land or the facility. On June 25, 1996, Barbe's removed the

cow from its perch (with plans to display it elsewhere); plans to demolish the plant and sell the acreage were underway by the Walker family. In that same year, Barbe's (established in Westwego in 1918) was sold to Southern Foods Group of Dallas, which had acquired Brown's Velvet Dairy in 1993. Southern moved the cow to its 1300 Baronne Street location, where it sat on a trailer in view from the street. The old Walker-Roemer building has been replaced by a self-storage facility.

LAKESIDE THEATRE (1965–1997)

The first first-run suburban theaters, Lakeside Theatre and Lakeside Cinemas I & II, opened in Metairie. By making movies that used to go downtown for their first local showings available to the suburban masses, such theaters helped seal the fate of the downtown picture palaces.
—*John Pope*[29]

Across Veterans from the five-year-old Lakeside Shopping Center and nearly adjacent to the newest Schwegmann's grocery store, W.H. Cobb and Associates opened the two-story Lakeside Theatre at 3526 Veterans Highway. This was a modern theater with two carpeted lobbies lit by chandeliers, rocking chair seats and a wide screen capable of handling Cinemascope, Cinerama and Panovision movies with surround and directional sound. The 728-seat theater opened with a 1:30 viewing of *Clarence the Cross-Eyed Lion* on August 5, 1965. Built at a cost of $300,000, its screen was twenty-three feet high and fifty feet wide.

Before Schwegmann's and the shopping center had been completed, the congregation of Trinity United Presbyterian Church broke ground on May 2, 1959, for a $60,000, 180-seat facility at 2805 Edenborn Avenue. In 1965, the New Orleans Bible Church made this its home until moving to Cleary Avenue on September 12, 1970. Soon after, Cobb converted the church building into Lakeside 2. In 1974, a structure was built connecting the two existing theaters to create the addition of Lakeside 3 and 4 and resulting in an amalgamation of three structures, each with its own ticket booth and concession stand.

Ironically, this movie complex suffered the same fate as the downtown theaters; competition from national chains operating megaplexes led to its demise in 1997. It was demolished and replaced by national retailers

OfficeMax and Just For Feet. William H. "Bill" Cobb, president and general manager of the Lakeside Theater, Beacon Theater and Westside Theater who also reigned as a king of Zeus, died a year after closing the Lakeside at the age of eighty-four at his home in Metairie.

AIRLINE HIGHWAY MOTELS, 1100 THROUGH 1300 BLOCK (1951–1997)

These hotels, once catering to families on vacation, fell into disrepair and disrepute. They were demolished in 1997 to make way for the gated, fifty-one-home Metairie Club Estates development.

Tulane Courts Motel (opened 1951)

Located at 1325 Airline and owned by Hosea Lafleur (who owned several along the highway through the years), this was once a nice motel offering "A Home Away from Home" with fifty modern rooms and suites, steam heat, free continental breakfast, an adjacent restaurant and sight-seeing tours. It later became the Sleepy Hollow Motel.

Town and Country Motel (opened 1953)

"Tomato salesman" and mafia kingpin Carlos Marcello, who has been linked by some to the assassination of President John F. Kennedy, handled much of his business from offices at the one-hundred unit Town and Country Motel, which opened in 1953 in the 1200 block of Airline.

Travel Inn (opened 1960s)

At 1131 Airline, the Travel Inn offered many modern amenities during its heyday in the 1960s, but by the late 1980s, it had devolved into a seedy hourly rate motel. It was here, in proximity to the high-class Metairie Country Club, on October 17, 1987, where Jimmy Swaggart's reign as a popular and successful televangelist ended when rival Marvin Gorman arranged for

photographs to be taken of him leaving the motel with a prostitute. Swaggart confessed, appealed for forgiveness and was defrocked.

AIRLINE "HIGHWAY" NO MORE (1997)

Representative David Vitter sounded the death knell on Airline "Highway" when, on August 17, 1997, he introduced the law that changed the name of the old road to Airline Drive in an attempt to rid it of its seedy image.

THE FUN ARCADE (1960–1990s)

Kiddie mechanical rides, including a Model T, space ship, helicopter, horse and Pony Express awaited young children at the Fun Arcade when Lakeside opened. Older children and teens enjoyed the coin-operated pinball, baseball, bowling and other machines. But there was a seamy side to this business, which was owned by Louis M. Boasberg, also the owner of New Orleans Novelty Company, which supplied pinball machines throughout

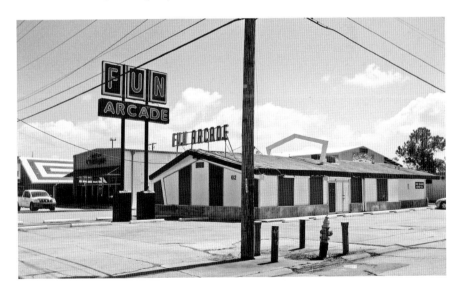

This Burger Chef was converted into the Fun Arcade in 1971. *Infrogmation.*

the state. He was convicted in 1973 of shipping pinball machines through interstate commerce to further illegal gambling business and of using the machines in such a business. One witness testified that as an employee of the Fun Arcade he had been instructed by Boasberg to pay out in cash for pinball winnings. Another witness stated that it had been understood that payouts in cash were tacitly acceptable.

The Fun Arcade was absorbed by an expansion of Porter-Stevens at Lakeside in 1972 and moved into the Burger Chef building at 612 Vets (corner of Focis near Dorignac's grocery). A sign of the times is reflected in newspaper advertisements that urged mothers to "Leave your kids at the Fun Arcade while you shop." Through the years, as technology changed, the Fun Arcade kept pace, adding video games in the 1980s and more-sophisticated offerings into the '90s. The old building is gone now, replaced by B&B Discount Pharmacy.

Fun Factory (1986–1999)

On November 22, 1986, the 17,500-square-foot Fun Factory opened near Power and Vets at a cost of $1.5 million. It was the idea of the child of the man who invented the Space Walk. Twenty-four-year-old Frank Spurlock included some inflatables in his venture, but this place also included a Sea of Balls (100,000 of them), thirty-five rides, the Cheeze Maze, bumper boats, party rooms and a catwalk net draped above the ground floor. The second story included a high-tech Discovery World with holograms, lasers, a shadow room and a Louisiana Hurricane exhibit, which simulated lightning, thunder, rain and wind—all experienced while staying safe, high and dry. The place was designed to attract young and old (it even had a Parents Room and Video Plex), but by the 1990s, it proved unprofitable and was closed.

The story behind the Fun Factory begins in 1959 with John Spurlock's invention of the "Space Pillow." In 1972, he erected an inflatable vinyl air bubble over a tennis court at the Bissonet Plaza Maned Downs Country Club. It was designed to protect players from the elements. By the late 1970s, he opened Spacewalk Tennis Club, a semi-indoor facility enclosed in an air bubble.

Ever the inventor, in 1975, Spurlock (an electrical engineer who had taught at Tulane and worked with NASA) was experimenting with an "Air Pack" designed to break the falls of victims in high-rise fires (one was used

in the movie *The Towering Inferno*); this led to the invention of the Space Walk inflatable. Other Spurlock designs included inflatable changing rooms where workers could safely don protective suits in factories handling hazardous materials, chutes to transfer crew members from ships to oil rigs and air domes to protect materials from rusting and damage. Space Walks can now be found throughout the country.

TIME-SAVER STORES (1954–1995)

The first Time-Saver store opened on Monday, March 8, 1954, at 1201 South Carrollton Avenue at Oak Street. Owned by L.C. Montgomery, it offered a unique service—motorists could drive *into* the store and park at display counters. Stressing quicker service, the store sold "staple and unusual products." Exterior signs advertised groceries, ice, beer, milk and the operating hours (7:00 a.m. to 11:00 p.m., seven days a week). The second Time-Saver opened at 1001 Metairie Road, identical to the first. In 1956, a fifth location at 4002 Gentilly Boulevard also offered barbecued chicken, ribs, beef, ham and pork. In the early years, the stores offered a full array of groceries, but it later dispatched the drive-in aspect and reduced the selection of goods.

By 1964, there were Time-Saver stores in fifteen locations in the GNO with more to come. In 1978, the company was sold to Dillon Companies Inc., a subsidiary of Kroger. By 1994, it operated 123 Time-Saver stores, most near New Orleans. E-Z Serve acquired them all in 1995. Many people miss these local neighborhood convenience stores and fondly remember Rosemary and Anna Mae hawking Time-Saver po-boys with mynez on TV commercials.

OLD BUCKTOWN (1850s–2005)

Lillian Razza's Bucktown home was built high on pilings in the 1890s on the Seventeenth Street Canal on "free land" by her father, Adolph Shultz, who fought in the Union army before settling in the village at age fourteen. He married Mary Nieman, and they had eight children, raised in the seven-room cottage that had survived countless storms and hurricanes by the time Frank Schneider wrote of it in 1984. Lillian recalled the front yard with its lush garden and vines protecting the home from summer sun and the two milk cows, ducks, chickens, deer and rabbits roaming there.[30]

The village took its name, according to Lillian, from a man who often shared freshly hunted buck deer with his neighbors, who nicknamed him "Buck" Wooley and then began to call their community "Buck's town." She remembered when more camps, built by hunters, trappers and fishermen, sprang up along the canal and then westward along the lake and when Alfred Bonnabel built a schoolhouse there, a two-room structure (which later become her brother Ralph's "Fresh" Hardware Store).

As a schoolgirl, she and her classmates were rescued from a storm as their boat nearly capsized by Captain John Bruning, who watched out for the safety of his neighbors from the cupola of his home, which stood until Hurricane Katrina. "He was our hero," said Lillian. He was also the owner of Bruning's Pavilion, the most popular camp on the canal, where brass bands played on Sundays. Lillian remembered places named Lallapazza, Lone Star and Fresh-Air Cottage.

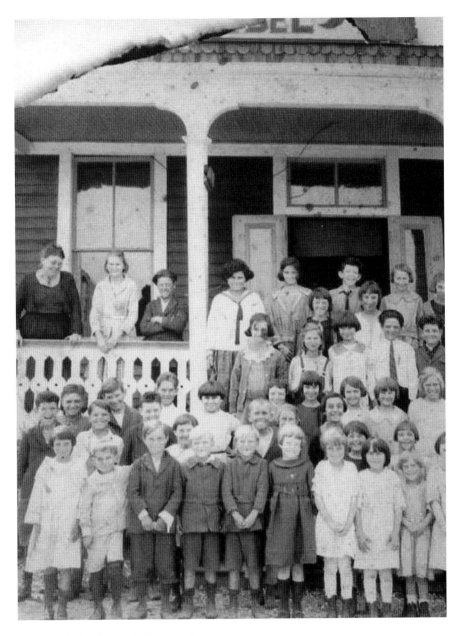

Bonnabel Schoolhouse. *Christle Bertoniere.*

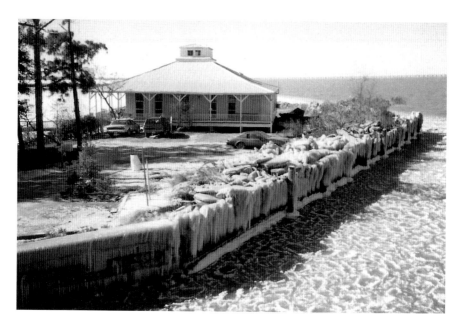

The Bruning home, 1989. *Lynn Markey Accardo.*

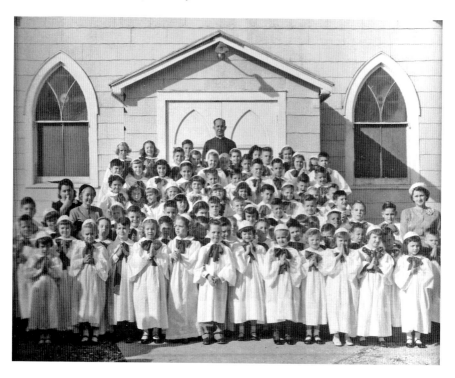

First Communion, St. Louis Chapel, 1951. *Laverne Forson Patrick Amore.*

Schneider followed up on Lillian's life story on July 2, 1984, in an article titled "Another Look at Bucktown Beginnings."[31] She recalled homes with unlocked doors, when the Crahans owned the only grocery in the village and when peddlers plied vegetables, sewing cloth, clothes poles, brooms and mops. In addition, itinerant knife sharpeners, chimney sweeps and begging nuns left her wondering why they would come to such a poor community.

Lillian recalled neighbors hosting penny parties in the early 1900s to raise funds to build St. Louis Chapel, high on stilts. And she remembered a frog-filled lagoon rife with choupique and gars. It later became the location of St. Louis King of France School.

Most of what Lillian described is gone now. All that remains are the new parish church and school, her beloved Lake Pontchartrain and the much-changed Seventeenth Street Canal.

JEFFERSON AND LAKE PONTCHARTRAIN RAILWAY (1853–1864)

Later taken over by the N.O. & Carrollton Railroad, the Jefferson & Lake Railway began operation on April 14, 1853. Although short-lived—its last trip was on November 28, 1864, under Union occupation—it enabled Bucktown to boom.

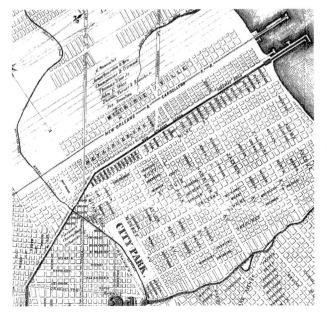

Nestled between the paper suburbs of Metairie Ville and Metairieburg, the railroad ran from Southport near the river along the Seventeenth Street Canal to the Port of Bucktown, where a ferry dock extended well into the lake, allowing for transport to the north shore. *AC.*

Seventeenth Street Canal

A ditch running from near the river to the lake is thought to have first resulted from excavation to raise the bed for the railroad above the swamp and marshland and was considered for a navigation channel. By 1875, improvements to what was now called the "Upper Protection Canal" made it a vital source of drainage for sections of Metairie, Broadmore and Uptown. The City of New Orleans owns the canal and land immediately adjacent to it, but the property on both sides is in Jefferson Parish; therefore, the homes, camps and businesses lining it were on Jefferson Parish property. In 1899, steam-powered Pumping Station No. 6 (the oldest New Orleans/Metairie station still in operation) was completed at Orpheum and Hyacinth Streets in what is now Old Metairie.

Orpheum Avenue

The canal provided relatively safe harbor for the fishers, trappers and families who settled along it. The heart of old Bucktown was Orpheum Avenue, which runs adjacent to the west side of the canal. Homes, restaurants, bars, dance halls with jazz music and rental camps sprang up. Gambling, bootlegging and prostitution drew "outsiders," so the jail was located in the midst of it all. The Brunings opened a restaurant in 1859 that became the third-oldest restaurant in the GNO; only Antoine's and Tujaques predated it.

Given its location, Bucktown was plagued by storms and hurricanes. A 1905 storm resulted in flooding so high that waters reached back to Metairie Road, followed by a 1906 storm that caused flood and wind damage. A 1914 fire ruined twelve homes. But in an earth, wind and fire scenario, it was earth that caused Bucktownians the most lasting struggles. By 1915, structures on the east side of the canal were on dry land, but west-side camp owners said they had also been on dry land until the canal shifted through the years due to dredging. That same year, a storm wrecked half of the fifty homes, and all of them were damaged.

During and after World War I, gambling flourished in the bars and restaurants. Before the Hammond Highway opened, the only way to reach Bucktown by land was via the West End streetcar (two cars coupled together) to West End and then through the park and across the Gap Bridge. In 1930, the Sewerage and Water Board (S&WB) dredged the canal again.

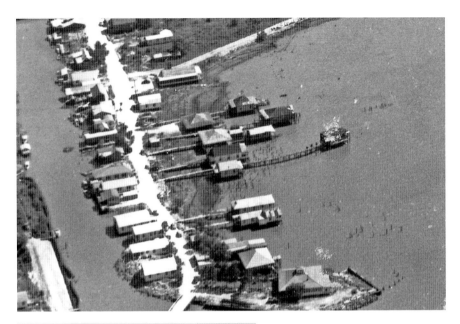

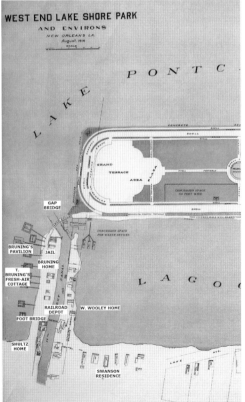

Above: A 1949 view of homes and businesses along the canal. *Maunsel White*.

Left: A 1914 illustration of West End and Bucktown. Note that the parish line is some distance east of the canal. *AC*.

St. Louis Church (1915–1959)

Alfred Bonnabel donated the land for and was in attendance at the dedication of St. Louis Church at Carrollton Avenue and Ash Street on Sunday, April 11, 1915. The *Times-Picayune* declared the "Catholic Edifice at East End One of the Prettiest in New Orleans." Father B. Enis served as pastor. That same year, the church was used for hurricane evacuation until it was threatened and villagers moved farther inland to the pumping station. Ground was broken for the present church on December 23, 1959. St. Louis King of France School opened with forty students in first and second grades on September 8, 1953.

Alligator Hunters and Breeders (through the 1960s)

Before Metairie's development as a suburb of New Orleans, a vast, treeless, grass-laden prairie marsh spread back from the lakeshore, interlaced with bayous fed by the lake. This environment, rife with seafood, fowl, deer and other wildlife, was also a breeding ground for thousands of alligators. Many Bucktown residents made their living by fishing, crabbing, shrimping, trapping and hunting. Even before the land was drained by canals and pumps, by the 1920s, the gator population was dwindling as result of hunting and egg collection.

In the early 1920s, gator hunters collected seventy-five cents per foot for live ones and three dollars per eight-foot hide from dealers as far away as Germany. A good hunting trip could result in as many as sixty of these. Eggs were also sought for hatchlings—nests might hold as many as forty of these.

When dealers sought hides, hunters approached the beasts and, at a distance of eight to ten feet, slayed them by hurling a hatchet into the soft spot on top of their heads, stripped the hides on the spot and left the carcasses behind. (Alligator meat was not considered a delicacy in those days.)

When live gators were sought, an elaborate ancient ritual was required in order to capture them without injury. After the gator's burrow was located, the hunters began a series of gator-mimicking grunts to lure the animal from its hole. Having accomplished this, the hunter approached the prey head-on, calmly stooped down, placed a hand under the snout, brought the thumb over the snout to clamp the jaws, swerved around to straddle the

gator using his feet to hold the tail from flailing, bound the snout shut with heavy twine and then tied the gator's legs behind its back. Some daring hunters, on spotting a gator at large, swiftly jumped on the creature's back and bound it as described.

One of the leading alligator hunters was John "Johnny" M. Lestrade, who also fished and crabbed in the early years of the twentieth century. His hunting ground was between Bucktown and Kenner, and he made his headquarters on Alligator Bayou, which consisted of a shack supplied with hunting supplies, a bed, a stove, provisions and barrels of pickled gator meat for crab bait. He made his home on Lake Avenue, was game warden in the early years and raised a large family. Lestrade died on November 25, 1964, at the age eighty-three but is still remembered by many older residents.

J. ("Junior") and Murl DeFreitas raised alligators on their property at Mayan Lane and Picayune (where they also ran a seafood shop) behind Ralph Shultz's hardware store. Emile "Nellie" and Alice Hamilton had a gator pond in their backyard on Carrollton at Plaquemine, near what is now R&O's restaurant. Sidney Patrick had one at his parents' home near the Bonnabel Canal pumping station. Many residents still remember these and express surprise that they might be considered out of the ordinary. They recall feeding the gators melts (cow spleen), watching them being skinned, escapees ambling down sidewalks and an occasional man riding large, snout-muzzled gators out of the woods and swamps after capture—out of what is now the Bucktown subdivision.

Ballard's (1920s)

When Orleans Parish officials cracked down on gambling in the 1920s, Jefferson Parish became a gaming mecca, as the law turned a blind eye. Before there was the exclusive Metairie Country Club in Old Metairie, there was Ballard's "Metairie Country Club," a posh gambling house on the Seventeenth Street Canal. The place was allegedly owned by Fred P. Miller, who was arrested in 1921 by Sheriff John Dauenhauer—only after the sheriff was ordered to do so by District Attorney Conrad Buchler after Senator Allen H. Johness filed a suit alleging illegal gambling there. Damning evidence included telephones in hog pens and chicken yards as well as gambling paraphernalia in Jefferson Parish District Attorney Buchler's garage on the adjoining property.

The club's officers included Miller and Jefferson Parish grand jury member J.J. McLachlan, who was also an alleged doorkeeper. Witnesses for the defense included: Gretna's mayor, an alderman and a candidate running for city marshal; a Jefferson Parish police jurist and grand jury member; and a state board of health inspector.

Front-page headlines reported the proceedings: "Courthouse Filled With Spectators…'BALLARD'S' FIGHTS FOR LIFE…OBJECT OF LEGAL ONSLAUGHT." In the end, Judge Prentice Ellis Edrington Jr. dismissed the case.

Swanson's (1922–1984)

As a youth, Frank William Turan Swanson was an outstanding swimmer with the East End Athletic Club and had hunted ducks and snipe for market, bringing large bags of birds to buyers at East End who then shipped the goods far and wide. He was known as one of the best marksmen in the area and was widely acknowledged as an outstanding fisherman—one of the first to catch a tarpon within city limits on Lake Pontchartrain. He also served the community as deputy sheriff and operated the Bucktown jail.

In 1922, he opened the Yellow Dog Saloon, which served all the boiled seafood one could eat as long as one imbibed his ten-cent schooners of beer. After success with the saloon, in 1926, he and his wife, Julia Pfeiffer, opened Swanson's Sea Food Restaurant, the floor of which was clearly marked with a line designating the half of the building located in Jefferson Parish, where gambling was illegal but mostly ignored by local authorities. The Swansons lived at 1849 Orpheum, along the canal.

A May 1948 fire destroyed the restaurant and the neighboring My-O-My Club (Bruning's had minor damage). Frank and Julia rebuilt the business, which became so popular that celebrities such as Guy Lombardo dined there. By 1953, Swanson's boasted of "Delicious seafood in air-conditioned bliss." Frank passed away in 1956 at the age of sixty-four.

Vincent Aiavolasiti took over the restaurant in 1968 and added "aged K.C. Steaks and authentic Italian food." In 1975, Bill Summers stepped in and renamed it Swanson's Flagship. The restaurant returned to Swanson ownership in 1978, when grandson Danny Mayer bought the business. When Danny passed away in 1979, the doors were closed for good (in October

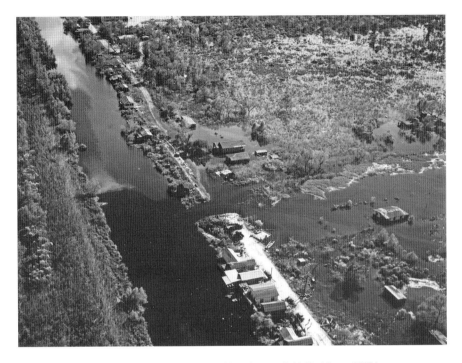

Seventeenth Street Canal after the unnamed hurricane of 1947. *Maunsel White*.

1984, the building burned to the ground). The Swanson family legacy lives on. In 1975, Frank and Julia's grandson Dennis Lacoste and his wife, June, opened Dennis' Seafood in the suburbs.

After World War II, the large gambling resorts failed, but the restaurants thrived. The worst storm since 1915 came in 1944. The jail closed in 1945—kids played for many years after in the tiny structure. After the great storm of 1947 (a reversal of Hurricane Katrina—the levee broke on the Jefferson Parish side, flooding back to Metairie Road), many homes were not rebuilt along the canal. A good many Bucktownians moved close by on dry land (the swamps having been drained) to what they referred to as Buck Vista (a playful snub at the nearby upscale Lake Vista development). This was the beginning of the end of housing on the canal. Suburbanization of Metairie in the 1950s increased the demand for nearby seafood, and fishers prospered, mooring their boats at docks along the canal.

THE WHITE HOUSE RESTAURANT (1947–1981)

Charlie Watson's White House bar and restaurant at 422 Hammond Highway had scheduled a grand opening when the 1947 hurricane left it flooded to the ceiling. After drying out, it became a very popular Bucktown venue for seafood and beer and gambling, and it had a snowball stand for the kids. In the early 1970s, Benny Compagnano ran it as "Benny's White House" and brought in live orchestras for dancing. James O'Connor acquired the place in 1974 and operated it again as the White House.

In 1981, after thirty-four years at the curve that led to Chickasaw Street, a fire damaged the building. O'Connor developed plans to build a fifteen-story, forty-eight-unit condominium on the site that would include the adjoining property of Charles Turan's abandoned shrimp-processing plant. Ten years later, Turan acquired the White House property, and the condo plan was floated again. A decade later, after years of wrangling over zoning variances and historic integrity, a condo went up in 2002. The $15.5 million, thirty-unit, seven-story Fleur du Lac complex offered panoramic views of the lake (while blocking them from longtime residents) at an average cost of $500,000 per unit. Pontchartrain Place condos was built adjacent to it. The Brown Foundation built a third high-rise between Seminole and Mayan.

Charlie Watson moved across the lake in 1984 and took the old Big Bear's Sno-Balls stand with him. His grandson Josh began selling snowballs and takeout roast beef po'boys from it in 1990, using his grandparents' White House recipe. His brother Matt opened other Bear's locations, which continue to operate today.

LAKESHORE THEATRE / "BUCKTOWN SHOW" (PROBABLY MID-1950s–1960s)

The two-story cinder-block neighborhood structure that housed shows at 1356 Seminole is remembered by old-timers as having fans blowing over ice blocks for "air-conditioning." It was operated by the Ouber and Skinner families. The building still stands, renovated into a four-thousand-square-foot residence.

EAST END BAKERY (1950–1993)

In 1950, Henry and Mamie Schwartz opened East End Bakery at 300 Hammond Highway. Many Bucktownians fondly recall Henry's Russian cake, hot French bread, doughnuts, brioche, birthday cakes and more. Kids loved the array of candies behind the glass case, the giant pickles, the comic-book stand and the claw machine. Fishermen could run up a tab for (and enjoy) cigarettes and beer there. In 1980, Roland and Ora Mollere opened a tiny restaurant (R&O's) in a back room. The Schwartz family operated the bakery for forty-three years until Henry's death at the age of eighty in 1993. The old building has been demolished, with a much larger R&O taking its place.

R. SHULTZ'S "FRESH" HARDWARE (1908–1993)

School director Alfred Bonnabel dedicated a two-room schoolhouse in Bucktown on June 14, 1908, on land he had donated. In attendance was Adolf W. Shultz, superintendent of schools, whose son Ralph would later call the schoolhouse his home and business.

During the 1947 hurricane, the school floated (local lore tells us) to Ralph Shultz's property. He purchased it, shored it up and turned it to face the road—and there it stayed for four decades at 1720 Lake Avenue as R. Shultz's "Fresh" Hardware and his residence. As the story goes, Ralph added "Fresh" to his general store and bar sign during Prohibition to let patrons know he had a fresh keg of home-brewed beer on tap. He also sold trawl, crab and crawfish nets, bait, tackle, boats and motors— just about anything needed to capture the bounty of the lake. He had gas pumps, wood floors, a jukebox, ancient hardware, cold beer and soft drinks. He sponsored kids' ball teams and taught them to play pool in the lean-to he added to the old schoolhouse (which also served as a poker hall). He carved decoys from cypress roots that he used to hunt for duck. He played the violin. And he remembered when the land comprised beautiful cypress swamps and miles of prairie marsh cut through by streams and bayous.

Steve Duplantis, Shultz's grandson, tells us that the hardware store closed sometime between 1982 and 1985. In the late 1980s, the building housed Shultz's Net Shop, operated by Ralph's daughter Joan Duplantis and her

Roy Schlaudecker in the store, 1962. *Donna Schlaudecker and Roy Schlaudecker.*

nephew Ernest Shultz. The old school building and the house behind it were demolished in 1993, replaced by a Domino's Pizza.

Ralph had ten siblings, including Mrs. John C. (Grace) Bruning. In 1975, at the age of seventy-six, he was crowned King of the Blessing of the Fleet celebration when he was one of the oldest men in Bucktown still actively fishing and crabbing. He was a founding member of the East End Volunteer Fire Department, a deputy sheriff and a member of the Bucktown Fisherman's Association. Shutlz died in 1994 at the age of ninety-five.

WALTER'S PARK (1970s–1980s)

After Melba Fuchs Tarantino passed away in 1973, her husband, Walter, began constructing a park on the lakeshore at Homestead Avenue near their home in her memory. He cleared brush from the land, hauled shells in buckets to make pathways, created benches and fences from driftwood, made swings from washed-in crab-trap ropes and tires and decorated this little wonderland with objects washed ashore. Walter died in 1985 at the age of seventy-seven while working in his beloved little park, where he had welcomed all.

EAST END SCHOOL (1940–1996)

Bucktown's first public school was built in the 1800s; a new one replaced it in 1908 (the Bonnabel/East End School). For the 1940–41 school year, a new East End Elementary School was opened, located at a new site at 1309 Lake Avenue on property valued at $4,000 in 1936 but sold to the school board four years later (in 1940) for $12,000. Sitting on two and one-

East End School classroom, 1950. Fifth-grade teacher Earline DeCuir is at far right. The students are, from left to right, (*front row*) Emile Hamilton, Noel Singer, Ursula Lestrade and Robert Arms; (*middle row*) Deanna Johnson, Clarence Thiac and Joan Borgstede; (*back row*) Ralph Cleary, Sylvia Bertoniere, Margie Cookmeyer and Herbert Schlaudecker. *Noel Singer Belew and Jimmy Mendoza.*

fourth acres, the raised, two-story, wood-frame and barracks-style building was constructed so solidly on wood pilings that it withstood every storm. It was used for hurricane evacuations. A story of particular interest tells of the mother's club protest strike after the storm of September 1948, when mothers refused to allow their children to attend school until the damaged cesspool was repaired, the washed-out road refilled and the eroded levee raised and repaired. After three days, the mothers achieved their aim.

In 1961, another East End School (renamed in 1972 for its first principal, Marie Riviere) was built up the road at 1564 Lake Avenue. The old one was used as the Lakeside School for Special Children and then for administrative offices and community education. In 1996, the building was demolished and replaced with the Breakers, an upscale gated apartment community.

FITZGERALD'S (1932–1998)

In 1915, Margaret Bruning and Maurice J. Fitzgerald celebrated their wedding at the Bucktown home of her parents. They opened Fitzgerald's Seafoods Restaurant in 1932 on the little site that would later become Maggie and Smitty's Crabnett, and they later moved to a seven-thousand-square-foot building at 1928 West End Park. Their son, daughter and their spouses joined the ranks. For a time, gambling and slot machines were as readily available as the fried softshell crabs and boiled seafood. In 1960, the wide porches were enclosed and a thirty-ton air-conditioner added—gone were the lake breezes. Hurricane Hilda damaged the restaurant in 1964, but the family repaired it and kept it going strong. Margaret and Maurice celebrated their fiftieth wedding anniversary there in 1965 at the ages of sixty-seven and seventy-eight, respectively. Margaret passed away in 1966. Maurice died in 1976. Maurice Jr. took over the kitchen and management and ran it very well, but by 1989, the glory days of West End had come to an end. He sold the restaurant in 1989, but it continued in operation until Hurricane Georges (1998) damaged it beyond repair.

MAGGIE AND SMITTY'S CRABNETT (1963–EARLY 2000S)

Brother and sister Marguerite and Lloyd "Red" F. Hemard opened the Crabnett in 1962. Elaine ("Smitty") was their sister and nonworking partner. Maggie (who had worked at Fitzgerald's) and Red (an electrician

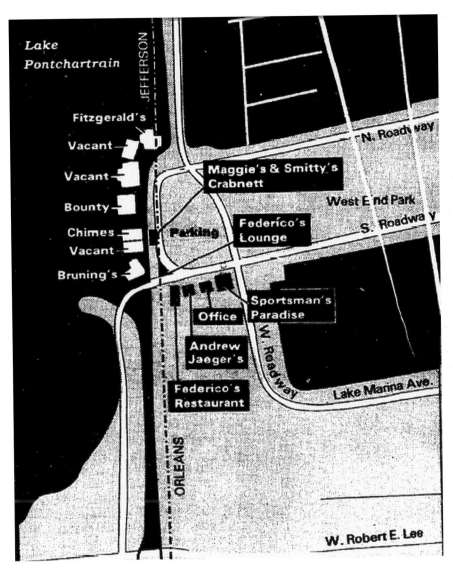

West End businesses, 1987. *TP.*

by trade) produced gumbo, boiled and fried seafood and po'boys in a tiny indoor kitchen with a small dining area. A large outdoor seating area was offered as well.

Maggie and Red persevered through years of storm damage, the East End's and the West End's general demise in the 1980s and even Hurricane Georges, which took out Bruning's and Fitzgerald's. But after the death of

Red in 2001, the old landmark closed down. Many remember the cats that were welcome to dine there. Some old-timers still swear by Miss Maggie's gumbo and Red's seafood platter.

Homes Along the Seventeenth Street Canal

In 1963, the New Orleans Sewerage and Water Board (S&WB) ordered the removal of all boats and structures along the canal from the lake to the pumping station. If owners did not comply, the S&WB stated that it would remove said structures, charge owners for the cost and prosecute them for trespassing if they returned. It was stated that the canal was strictly a drainage conduit, not to be used for navigation, but the S&WB relented and allowed docks to remain, under the condition that fishers clear the canal of other obstructions. In 1968, the S&WB ordered all structures cleared from Hammond Highway to the pumps for a proposed 1968–1969 four-foot levee-raising.

In 1974, after the S&WB threatened to evict the remaining homes, camps, boats and slips, the Bucktown Preservation and Improvements Association

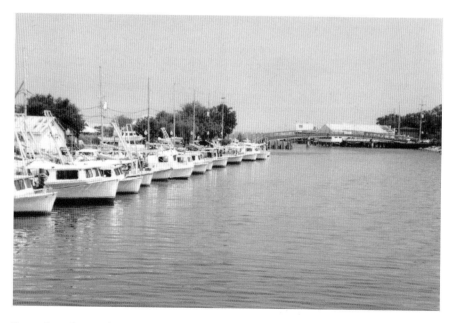

Boats along the canal with the Gap Bridge and Bruning's in the distance. *Bitterman.*

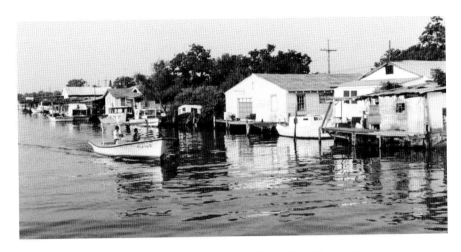

Seventeenth Street Canal, Bucktown, circa 1968. *Historic New Orleans Collection.*

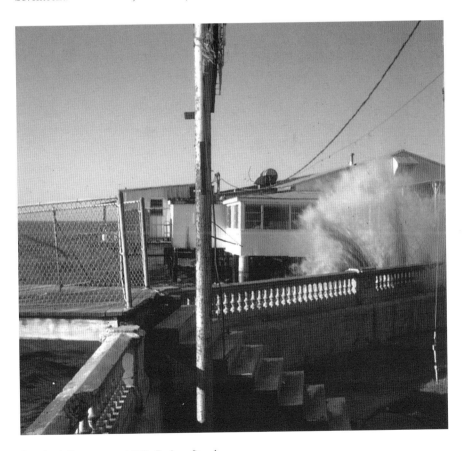

Bruning's Restaurant, 1973. *Barbara Spengler.*

was formed. S&WB wanted to dredge and widen the canal to 140 feet because a 1973 rain event had caused flooding on Old Metairie's Northline Street and in parts of uptown. S&WB obtained a U.S. Army Corps of Engineers (USACE) permit to dredge and widen from Hammond Highway to the lake in 1979. But the association prevailed; the structures were spared.

In 1980, Jefferson Parish had plans for a Bucktown marina, and the S&WB again sought to dredge and widen two and a half miles of the canal from the lake to the pumping station and clad it with sheet-pile walls on both sides, claiming that pilings and dumped materials impeded the flow after another uptown flood. In 1981, S&WB sued to remove structures on the west side; camp owners claimed squatters' rights. In 1982, 125 slips and camps were threatened when S&WB sued to remove all obstructions from the lake to Hammond Highway.

The S&WB finally did expropriate property to widen and dredge from the Hammond Highway to the Gap Bridge in 1988. It appropriated $500,000 for the purchase of eight camps on the Jefferson Parish side. Demolitions began in May, and boats were barred from the canal. Mabel Swan (sister of Judge John Boutall) used the money the S&WB had given her for the loss of her property to move her 1895 home to the other side of Orpheum, where seven camps were allowed to remain. In 1989, new boat slips took the place of camps, new street lights and landscaping were added and the area was named Bucktown Village Park. The wooden Gap Bridge was replaced with a cement and steel structure.

Hurricane Georges struck an almost final blow when it took out more homes. Following Hurricane Katrina, the USACE removed all vestiges of the past along the canal. Nearby "Buck Villa" homes were being demolished and replaced with McMansions.

BRUNING'S RESTAURANT (1859–2005)

In 1859, Theodore Bruning (who had married Mabel Hamilton) moved his Carrollton restaurant to Bucktown. No levees or roads flooded from September to April, so Mr. Bruning opened his doors from Easter Sunday until Labor Day of each year. In 1886, Bruning's moved to the location it remained in until Hurricane Georges badly damaged it in 1998. The restaurant moved to a building next door, where Bruning's served seafood until Hurricane Katrina destroyed the West End / East End area. For a time,

Bruning's had dancing waitresses and rows of slot machines. In the early 1900s, J.C. Bruning owned and operated the White Squadron—forty-two white fishing boats (sixteen and eighteen feet long) that he rented out for fifty cents a day.

THE BRUNING HOME (1893–2005)

The landmark Bruning home was built in 1893 by Captain John C. Bruning, who was credited with saving many lives as he watched storms from the lookout on the roof of his house. After a 1910 fire destroyed much of the small community, he organized the volunteer fire department. In the 1950s, he served on the Jefferson Parish School Board. Bruning passed away in 1962 at the age of ninety-one. The home was destroyed by Hurricane Katrina.

SID-MAR'S OF BUCKTOWN (1972–2005)

The last of the old-time at-the-water seafood restaurants that once lined the Seventeenth Street Canal, Sid-Mar's began on Harrison Avenue in 1967 before Sidney and Marion Gemelli Burgess moved to 1824 Orpheum in 1972. Before their arrival, the old place had been Lenfant's bar, Ferdie's, Emken, Dee's, Bee's, Buddy Fuchs and Maybeth's. Marion cooked great Italian (including a wonderful Wop salad to go along with the fried and boiled seafood). Cold beer, screened porches and Lake Pontchartrain sunsets were all part of this unpretentious, utilitarian place.

In the mid-1970s, Marion was one of the founders of the annual Fourth of July Bucktown Blessing of the Fleet, with its old-time pirogue races. Sid-Mar's served as its unofficial headquarters. Proceeds were donated to Children's Hospital. World War II veteran and Purple Heart recipient Sidney Burgess passed away at the age of seventy-seven in 1993. Marion and their son Kent continued to run the restaurant until Katrina washed it away. Marion died in 2013 at the age of eighty-eight.

TWENTY-FIRST CENTURY

Introduction

Two movie theaters, many restaurants, several Airline Highway motels and the last bowling alley shut down after the turn of this century. Pat Gillen's bar was demolished, as was the old parish office building. Al Copeland's Christmas lights were removed, and the home they once adorned was demolished.

Kenner Bowl / AMF Kenner Triangle Lanes (1960–2000)

On the far end of Veterans from Paradise Lanes, the thirty-two-lane Kenner Bowl opened in 1960, but the highway was even more undeveloped here, and the facility was fronted by a massive shell-lined parking lot surrounded by land yet untouched by man. But it outlasted Paradise for a forty-year run, closing in June 2000. Located at 2300 Veterans Highway (technically a few blocks from the Metairie/Kenner border but patronized by many Metairie residents), the old building was demolished and replaced by a three-story, ninety-one-room Extended Stay America hotel.

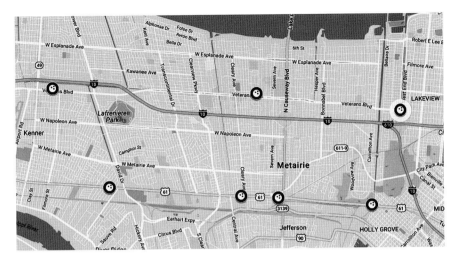

The Metairie area was the home of seven bowling alleys. Now there are none. *AC.*

EAST JEFFERSON PARISH INCINERATOR (1947–2000)

Built in 1947 at 912 David Drive at Airline, this facility was considered a modern means of managing municipal garbage, handling one hundred tons per day and serving the entire east bank of Jefferson Parish. Most residents simply called it the "Dump." Burning of wastes ceased in the 1970s, when the parish opted to move trash to landfills. The dump was demolished in 2000.

PAT GILLEN'S (1949–2001)

Richard J. Gillen opened his second barroom at 2024 Metairie Road in a newly built shopping center in 1949. His first bar was at 2215 Jefferson Highway, near Labarre. He started there in 1937 in the former grocery store on the first floor of his family home when it still had a cistern. He called his business Pat's Place, then Pat's Grocery, then Pat's Grocery and Market until, in 1940, he debuted Pat's, advertising it as "Jefferson Parish's Newest and Most Popular Nite-Club" with dancing to "Clancy's Famous Band" and a menu that included seafood, chicken and squab. By 1941, he was specializing in "Whole Fried Frog with French Fried Potatoes and toast"—all for a quarter.

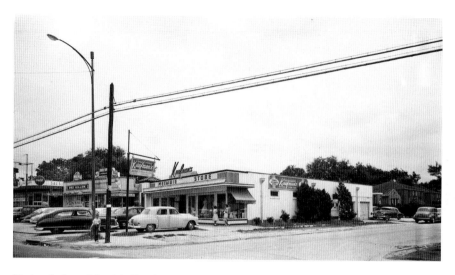

Undated photo, Metairie Road at Atherton Drive. Included here are Sal Talluto's grocery, Pat Gillen's Bar, Simon Streiffer wholesale distributor, Sal's Sno-Balls and Kaufman's Metairie Store. *LDL.*

In 1954, he moved his Jefferson location to 1715 Jefferson Highway at Deckbar, which operated there until 1968 or so. After Pat left, the building housed Tent Town, Trailor Town, m/f Seafood restaurant, Mother's Mustache, Riverbend Brewhouse, the Deck Bar and the Recovery Room, to name just a few, until it was demolished in 2016. There was a Pat Gillen's on Williams in Kenner as well as in the M.A. Green Shopping Center on Airline, but the most sorely missed is the one that stood on Metairie Road for fifty-two years.

It was a colorful place filled with colorful characters, to say the least. For example, the front-page news in the *Times-Picayune* on August 5, 1956, reported, "Metairie Shopping Area Offers Choice of Gambling—Handbook or 'One-Arm' Bandit Available." Two slot machines, in clear view, were paying out as much as seventy-five dollars on a good day. Across the street at the Pelican Bar (now Oscar's bar, formerly Melba's Ice Cream shop), one merely walked past the bar to an eighteen- by twenty-five-foot backroom crowded with some forty customers when the reporter arrived to view them checking on race results displayed on the wall. The bookie's cash was piled on a corner table. A screen door led to a back parking lot filled with cars. A patron described the long-running Saturday "neighborhood" poker games of which the house took a cut.

St. Patrick's Day parades were celebrated with gusto at Pat Gillen's until 2001, shortly before it (and the entire shopping strip) was demolished to make way for an AmSouth Bank branch (now a Regions branch bank). Richard Gillen (nicknamed "Pat" because he was born on St. Patrick's Day) passed away on January 13, 1974, but his name and his bar will long be remembered.

AMC GALLERIA 8 (1987–2002)

When this theater opened at 1 Galleria Boulevard in Metairie's newest high-rise on June 3, 1987, it offered state-of-the-art technology and amenities including surround sound, curved screens and seats with cupholders—the free popcorn refills were a nice touch. When it closed twelve years later on March 24, 2002, it had become outdated.

Poor attendance and declining profit led to the demise of this posh place on the seventh floor whose eight auditoriums each seated 175 to 375 moviegoers (1,900 total seats). As reported in the *Times-Picayune's* March 22, 2002 edition, the Galleria suffered the same fate of many other local movie houses; the New Orleans area had lost 76 screens at ten venues since 2000, leaving 110 screens at fifteen locations.

AL COPELAND'S LIGHTS (1975–2000S)

In 1975, Popeye's Chicken magnate Al Copeland decorated his mansion at 5001 Folse Drive for the holiday season. The following year, he added more lights. And so it went until 1978, when the display featured animated figures, 100,000 lights and a human Santa handing out candy to kids. The display grew more elaborate each for ten years until 1983, when sightseeing buses arrived and street venders hawked wares. Neighbors filed a lawsuit to halt the display. In 1985, the Louisiana Supreme Court ordered Copeland to shut off the lights and dismantle the rest. The following year, Copeland moved the display to his corporate office at 1333 Clearview, where the lights shone bright for four years.

Ever the mover and shaker, Copeland arranged for the display to be moved to the state capital in 1990, where his lights and figures, assembled by prison inmates and volunteers, surrounded the grave of Huey P. Long. A toned-down version with only one million lights (in accordance with the

law) returned to Folse Drive in 1991 to delight visitors until 2001, when they moved to City Park's Celebration in the Oaks. Then they went to Lafreniere Park, then back home, then back to Lafreniere.

When Copeland decided to move to Mandeville, officials there quickly nixed any plans he might have to display his lights. In 2008, the lights were donated to Jefferson Parish.

Al Copeland died at the age of sixty-four, after battling Merkel cell carcinoma, on Easter Sunday, March 23, 2008, near Munich, Germany, where he had gone to receive treatment for the rare but fatal condition. In 2010, his family demolished the mansion on Folse Drive, donating all salvagable materials to Habitat for Humanity. Al Copeland's holiday spirit still delights children each year in Lafreniere Park.

LAKESIDE CINEMA (1967–2000)

Lakeside Cinema opened in the rear of Lakeside Shopping Center in August 1967 with two screens. The complex grew to accommodate five screens by 1976. Owned by General Cinema Theaters, it closed on September 28, 2000. At that time, employees reported that average weeknight attendance had dropped to fewer than twenty.

The closing of Lakeside Cinema was (like that of the locally owned Lakeside Theatre) due to increased competition from newer megaplexes.

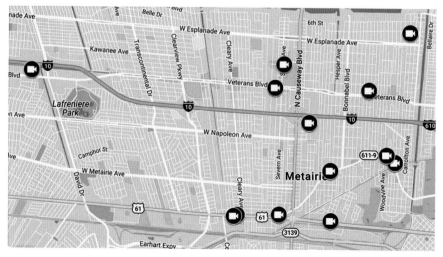

Metairie has had fourteen motion picture venues. At the time of this writing, there is only one, the AMC Clearview Palace 12. *AC.*

Twelve GNO theaters closed between 1996 and 2000; sixty-eight screens in nine theaters were lost between May and September 2000.[32]

Beach Brothers Furniture (1946–2001)

In 1946, Joe, Paul and David J. Beach opened Beach Brothers Furniture on almost an acre of land at 3627 Airline Highway between Shrewsbury and Turnbull. Their children hunted dove and rabbit near the store, whose property ran to Johnson Street. The second generation of Beach brothers, David's sons David, Jerry and Michael, continued the legacy, working with their father and mother, Anna Mae, in the massive two-story, thirty-thousand-square-foot building. Three generations of loyal customers bought their furniture here until the business closed in 2001 after fifty-five years on Airline.

Jefferson Parish East Bank Office Building (1957–2002)

The ribbon was cut at 3300 Metairie Road on October 19, 1957, for the $1.5 million, four-story glass-and-cement building to house all east bank parish agencies with the exception of the health unit and jail, which would be built at adjacent locations at the end of Metairie Road at Causeway. A reviewing stand was annually erected here for Mardi Gras and St. Patrick's Day parades for invited dignitaries and guests, including special-needs children and the elderly. The building was demolished in 2002.

Jefferson Parish East Bank Office Building, February 27, 1962. Charles L. Franck, *LDL*.

The Lobby Library (1966–2003)

Built in 1966 as the Jefferson Parish Library Headquarters, the thirty-thousand-square-foot building at 3420 North Causeway Boulevard was constructed as a warehouse for books to be circulated to local branches. By the 1970s, patrons from local branches began demanding direct access to the main collection, which contained more than 300,000 books. A unique system was devised by Parish Library administrator Maurice D. Walsh Jr. in 1978. Visitors entered a room in the rear of the building, told the librarian which books were wanted, and staff workers would retrieve the books (from behind closed doors). The warehouse shelving contained sliding drawers that were considered unsafe for the public to use. Deemed the "Lobby Library" because of this arrangement, it was one of the few public libraries in the country that did not allow users free interaction with its books.

In 1997, the Lobby's books were moved to the new 140,000-square-foot East Bank Regional Library at 4747 West Napoleon Avenue. The building was converted into the Causeway Head Start Center in 2003.

Weng's Garden (1970s–2003)

A 1988 *Times-Picayune* restaurant listing tells us that Weng's offered "Chinese Food and American Po-boys" in a "Casual" setting. It was so "casual" that it operated out of what appeared to be a freestanding garage at Metairie Road near Bonnabel. Weng's was unique—where else in town could one get Chinese and "American" po'boys at the same place decades before bahn mi became popular in the area? Lots of people swore by their hamburgers. The structure was demolished in 2003.

Toddle House / Liz's Café (1954–2004)

A franchise of the national Toddle House chain opened at 2567 Metairie Road in the summer of 1954, offering 24/7 service. It wasn't until the mid-1970s that a new business, Red Coach Diner, moved into the building where Liz Franz worked while her mother cooked. In the late '70s, it became the

Cottage Inn. Then, in 1984, Liz opened her own business there until 2004, when the land was leased to Omni Bank. In 2005, Liz's, as well as the nearby Coffee Cottage (which had formerly housed Henry's Po-boys and the Cedars Lebanese restaurant), owned by John Caluda, were demolished under the terms of the Omni Bank lease.

OVELLA'S / BROCK'S HOUSE / BARRECA'S RESTAURANT (1948–2005)

In 1948, Emile and Essie Ovella opened their restaurant and bar at 3100 Metairie Road, one and a half blocks off Causeway (then Harlem Avenue) on Metairie Road. These industrious longtime Metairie residents also operated a vegetable farm near Harlem and Metairie Road as well as a snowball truck.

During the 1960s Henry J. Brochaus took over Ovella's and renamed it Brock's House, offering the same type of local New Orleans restaurant fare; roast beef po-boys, fried seafood, cold beer (and oysters by the sack). In the early 1970s, the Ovella name returned when Emile's daughter Barbara ("Bobbie") and husband, Jerome ("Jerry") Sauer, took over the place. In the early 1980s, the restaurant was operated as Ovella's but under different business owners, including Kirby J. Baudin, who changed the name to KJ's Seafood in 1986.

Barreca's Restaurant, 2010. *Infrogmation.*

In the late 1980s, yet another name appeared on the (newly renovated) old building when David Barreca opened his restaurant there. It operated until Hurricane Katrina. (Neighbors remember Barreca's freely serving their families and others in its aftermath.) Barreca's then operated as a caterer and host to private parties until it was purchased by Creole Cuisine Restaurant Concepts in 2016.

To this day, the Ovellas are remembered fondly. And Essie's roast beef po-boys are still considered beyond compare.

AIRLINE HIGHWAY MOTELS (1940s–2011)

Back in the day, motels lined the highway. Beginning near the Kenner boundary, there was the Mardi-Gras Motel Court (9011 Airline), the Keystone (8825), Good Luck Tourist Courts (6201), Dixie Bell (6137), Rozal's (5825), Holiday Inn / Travel Inn / Knights Inn (5733), Martin's Hotel Court (5100), Deep South (5021), Oak Park Cabins (4901), Candlelight Inn (4801), Wigwam Village (4800), Mike's (4505), Rainbow (4307), Sugar Bowl Courts (4303), Home Sweet Home (4231), La Ville (4001), Orleans (3900), Metry Tourist Court (3807), Trade Winds (3616), St. Regis / Texas Court (3520), Twins Motel (3440), Prout's/Skyline Motel (now Aloha) (3300), Rossi Motel Court (2800), Flamingo/Cinema Hotel (2935), Villa (1929), Chestmar, (1395), Tulane, (1325), Town and Country (1225), Travel Inn (1131), Country Club Motel (1035) and the Sherwood (1015).

The infamous Sugar Bowl Courts on Airline and Houma/Central started out in the late 1940s as a nice place with steam heat and in-room phones. In 1989, scenes from the movie *Blaze* starring Paul Newman were filmed here. After being seized by the sheriff, along with the Rainbow Motel in the same block, the property was sold for $2.5 million in 2011 and replaced with a CVS. Just across Houma Boulevard, the Sweet Home Motel was replaced by a Pelican Pointe Car Wash.

In 2010, the sheriff seized and permanently shut down the La Village (just off Airline at 100 Manson Avenue, within a block of St. Christopher School) and the Trade Winds at 3616 Airline at Arnoult. In 2011, La Village was demolished by parish authorities. The Trade Winds was later razed and replaced with a Waffle House. Both were owned by Anil Patel, who pled guilty to tax fraud in 2013 for failure to report nearly $1.4 million in

revenue derived from the businesses. Remaining today are only Knights Inn (a Wyndham hotel), Texas, Keystone, Cinema and the seedy, hidden-under-the-overpass Aloha motels.

MUHLEISEN'S (1949–2012)

Since 1885, the Muhleisen family has served the New Orleans area. Their Metairie funeral home, opened in 1949, was located a block east of Labarre at 2929 Metairie Road. In the 1960s, Muhleisen also provided a twenty-four-hour, citywide ambulance service and was designated the "Official Funeral Directors for the Parish of Jefferson." The last funeral took place here in December 2012. The building has been demolished.

L.A. Muhleisen and Son funeral home, 2013. *Muhleisen's.*

GREAT WALL CHINESE RESTAURANT (1979–2014)

Leo Wang opened his restaurant at 2023 Metairie Road after emigrating from Taiwan. Three years later, he married and brought his wife, Shelly, to the United States. They operated the Great Wall, he as the chef and she as the hostess, until they retired in 2014. Their restaurant had housed, through the years, Metairie Appliances (1940s), Singer Sewing Center (1940s–1960s), Harde Furniture (1960s) and Charlie's Delicatessen (1960s and '70s). Today, another restaurant, Blue Line Sandwich Company, operates here, named for the old streetcar that used to pass there. The old tiles underfoot at the entrance still tell us that "SINGER" was once here.

The Great Wall. *Infrogmation*.

The other end of the shopping strip, 1940s. *Maunsel White*.

Houston's (1980–2015)

After thirty-four years at 4241 Veterans, Houston's closed in May 2014. A fixture on the highway in the Independence Mall since 1980, it was owned by Los Angeles–based Hillstone Restaurant Group, which decided to devote its efforts to the St. Charles Avenue location. In 2015, the building was bought by Creole Cuisine Restaurant Concepts (which acquired Barecca's in 2016) and operated as Boulevard American Bistro, managed by longtime Houston's veteran Robert Hardie, who is also a partner in the restaurant.

Tiffin Inn (1977–2015)

For thirty-eight years, owner Saleem Sabagh operated this pancake house, opening its doors in 1977 at 6601 Vets. Sabagh had no plans to discontinue serving his many loyal customers when his landlord failed to renew his lease to make way for a HomeGoods store.

Railroad Crossing on Metairie Road (1904–present)

More than one hundred years ago, on March 26, 1904, the New Orleans Terminal Company for the first time crossed the railroad tracks at Metairie Road and Frisco Avenue. With this event, Old Metairie lost its quietude and gained its first traffic jam (which continues today). Fifty-eight years later, in 1962, a $1 million plan to build an underpass here was dropped. Old Metairie residents and visitors can only hope that this crossing would be "lost."

Tony Angello's (1972–2016)

When it opened in 1972, it would have been easy to pass up this restaurant, which appeared to be a lovely home. It became a landmark at 6262 Fleur De Lis Drive at Harrison Avenue. For forty-four years, families and friends

met here for occasions, special or not, many patrons simply asking the waiter to "feed me." The food was Italian with a New Orleans twist, and it was delicious. Tony passed away in 2015 at the age of eighty-eight. After forty-four years, the restaurant closed on Saturday, December 24, 2016. Although Tony Angello's was not located within Metairie's boundaries, it is included here because of its proximity and the fond memories so many Metairie folks hold of the place.

NOTES

Chapter 1

1. Bruce Boudreaux, "Depression-era Memoir Shows Glimpse into the Past—The Late John Hertz Penned Nostalgic Story of Two Boys," Times-Picayune, May 20, 2015.
2. "First Cars Run Over New Loop Along Metairie, Many Passengers Carried between Seventeenth Street Canal," *Times-Picayune*, July 19, 1915, 4.

Chapter 2

3. Bezou, *Metairie*, 179.

Chapter 3

4. Gregory Keer, *International Bowling Industry* 18 (October 2010): 29.

Chapter 5

5. Bruce Boudreaux, "Memories of Neighborhood Stand the Test of Time," *Times-Picayune*, March 30, 2016, D01.
6. Ibid.
7. Frank Schneider, "The Perfect Place to Live Their Lives," *Times-Picayune*, June 29, 1984, 29.

Chapter 6

8. Howard Jacobs, "Youthful Samaritans Ease Patients' Lot," *Times-Picayune*, February 22, 1973, 9.
9. Emile Lafourcade Jr., "Fat City to Be East Jeff's Vieux Carre-Type Area, *Times-Picayune*, March 1, 1973, 10.
10. Bill Theodore, "Rename Fat City," *Times-Picayune*, October 6, 1973, 12.
11. Don Lewis, "Booming Fat City Mixes Business and Pleasure," *Times-Picayune*, July 14, 1974, 69.
12. Ed Anderson, "Reverse National Trend," *Times-Picayune*, March 17, 1974, 129.
13. "Donelon Urges Strict Regulations to Ward Off Fat City 'Slum'," *Times-Picayune*, February 14, 1975, 7.
14. Patricia Behre, "Fat City Struggles against Image," *Times-Picayune*, September 15, 1985, 126.

Chapter 7

15. Bill Grady, "Ex-Drummer Hears Own Beat—Entrepeneur Keeps His Dreams Big," *Times-Picayune*, March 26, 2000, B01.
16. *Times-Picayune*, United Theatres Inc. (advertisement), October 2, 1942.
17. Bruce Boudreaux, "Old Jefferson Bids Adieu to Iconic Frostop, Other Venues," *Times-Picayune*, March 2, 2016, D01.

Chapter 8

18. Aaron Smtih, "Zodiacs Return to WC for 45th Year," United States Bowling Congress, http://www.bowl.com/news/newsdetails.

19. Bruce Boudreaux, "About the Good Times at the Do Drive In, Residents Reminisce. 'Cruising Down Memory Lane,'" *Times-Picayune*, July 29, 2015, D01.

20. Ibid.

21. Janet Wallfisch, "After a Half-Century of Baking, Her Confections Are Still Perfections," *Times-Picayune*, September 22, 1985, 44.

22. "Aereon Theater Will Open Today," *Times-Picayune*, December 3, 1948.

23. "Retailers Rap LA. Pardon Unit," *Times-Picayune*, January 17, 1962, 3.

24. David Baron, "Sena Mall Will Close Its Doors," *Times-Picayune*, April 7, 1989, L31.

25. Mike Scott, "A 'Rocky Horror' Flashback: Remembering the Cult Classic's Decade-Plus New Orleans Run," *Times-Picayune*, October 19, 2016.

Chapter 9

26. John Burke, "Flashbacks," *Times-Picayune*, January 5, 1992, D14.

27. George Sweeney, "Curtain Closes on a Bowling Paradise," *Times-Picayune*, September 20, 1995, D8.

28. "Theater Offers Twin Panorama," *Times-Picayune*, August 17, 1967.

29. John Pope, "Saenger Chronology," *Times-Picayune*, October 2, 2013, A10.

Chapter 10

30. Schneider, "The Perfect Place to Live Their Lives."

31. Frank Schneider, "Another Look at Bucktown Beginnings," *Times-Picayune*, July 2, 1984, 46.

Chapter 11

32. Martha Carr. "A Final, Sad Scene at Theaters—Lakeside, Esplanade Shut Doors, Cinemas Closing Signals the End of Era, Patrons Lament Closing of Cinemas, Lakeside, Esplanade Not Able to Keep Pace with Megaplexes," *Times-Picayune*, September 29, 2000, 9.

BIBLIOGRAPHY

Bezou, Henry. *Metairie: A Tongue of Land to Pasture*. Gretna, LA: Pelican Publishing, 1973.

Bordenave, Justin F., and Jefferson Parish (LA) Police Jury. *Jefferson Parish Yearly Review: Official Publication of the Police Jury*. New Orleans, LA: J.F. Bordenave, 1935–81.

New Orleans Times-Picayune, http://infoweb.newsbank.com/resources/doc/nb/news.

Swanson, Betsy. *Historic Jefferson Parish: From Shore to Shore*. Jefferson Parish Council, 1975.

INDEX

ABOUT THE AUTHOR

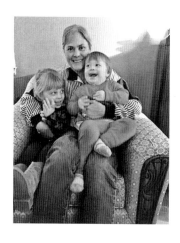

A native of Fort Ord, California, Catherine Campanella's anomaly of birth was reconciled at the age of six weeks, when her father was discharged from the U.S. Army and returned home with his wife and two children to New Orleans. Just a few years later, the family moved "way out" to a new suburb on the western edge of Metairie surrounded by large tracts of open land, where blackberry picking and hiking through woods were childhood pastimes. Having grown up witnessing Metairie change and grow, Cathy developed an interest in its history, which is the subject of this new book.

An LSU graduate with a BA in fine arts, Cathy chose a career in teaching (MEd, University of New Orleans), becoming a technology coordinator and early proponent of the educational value of the Internet. New Orleans History—Lake Pontchartrain (http://www.pontchartrain.net/www.pontchartrain.net) was her first attempt to compile a cultural overview as a pictorial history of the lake. *Lake Pontchartrain* (Arcadia Publishing, 2007) culminated this endeavor in a print edition. Now a retired educator, Cathy's interest in writing and research has grown to include the books *Metairie* (2008), *New Orleans City Park* (2011), *Legendary Locals of Metairie* (2013) and Images of Modern America: *Lake Pontchartrain* (2015), all released by Arcadia Publishing.